The Campus History Series

OKLAHOMA STATE
UNIVERSITY

The Campus History Series

OKLAHOMA STATE UNIVERSITY

Dr. Charles L.W. Leider

ARCADIA
PUBLISHING

Published by Arcadia Publishing
Charleston, South Carolina

Library of Congress Control Number: 2016950306

For all general information, please contact Arcadia Publishing:
Telephone 843-853-2070
Fax 843-853-0044
E-mail sales@arcadiapublishing.com
For customer service and orders:
Toll-Free 1-888-313-2665

Visit us on the Internet at www.arcadiapublishing.com

For the generations of architects, landscape architects, planners, and visionaries whose passion and commitment have shaped Oklahoma State to this day and into the future

CONTENTS

ACKNOWLEDGMENTS

I wish to thank my wife, Yuvone, and my sons Chuck and Steve Leider—especially Steve because of his work with me in historic preservation—for their support and encouragement to publish the history of Oklahoma State University (OSU) based on its use of campus master plans to guide its growth and development from the time of its inception to the present.

To celebrate the OSU centennial in 1989, my special topics class, Case Studies in Historic Landscape Preservation, decided to re-create the lost 1930 master plan, which strongly influenced the development of the campus. I wish to thank the landscape architecture students William M. Cole (team leader), Kyle Clayton, Donna Decatur, George Fox, Scott L. Kilgo, and Myra Ann Roberts, who participated in this effort under my direction in re-creating, interpreting, and documenting the plan using the Historic American Landscapes Survey (HALS) requirements. In addition, I also wish to thank Dr. William Bryans, of the Department of History, and Prof. Nigel Jones, of the School of Architecture, who served as project advisors. A thank-you is owed to David Peters, of the OSU Special Collections, for his helpful assistance in providing the photographs for this publication. I also wish to thank Lance Hinkle, of the university bookstore in Oklahoma State Student Union, for supporting sponsorship of this book. It was this student project for the OSU Centennial that acquainted me with the development of the OSU campus and motivated me to further study the campus's development history.

The 25-year master plan, completed in 1930, established the Neo-Georgian architectural style, building materials, and colors for the campus under the leadership of President Bennett from 1928 to 1957. The drawings the students developed in re-creating the 1930 OSU master plan have been incorporated in this work to illustrate the development of the campus during this key period 1930–1959. A full record of the drawings that were developed in the re-creation of 1930 master plan can be found online in the HALS collection in the Library of Congress at http://memory.loc.gov/ammem/collections/habs_haer/ or in Special Collections, Edmon Low Library, Oklahoma State University, Stillwater.

Some of the rich information contained in these pages would not have been possible without several detailed interviews. I would like to thank the following people who allowed me to interview them: Nigel Jones, architect, Long Range Planning Office, Oklahoma State University, Stillwater; Clare Woodside, planner/architect, Benham Company, Oklahoma City; Joe Howell, landscape architect, Howell and Vancurren, Tulsa; and Dan Alaback, landscape architect, Alaback Design Associates, Tulsa.

Unless otherwise noted, all images are from Special Collections, Edmon Low Library, Oklahoma State University. My gratitude is also given to the Library of Congress, the HALS Collection of the Department of Interior, and the National Park Service for having contributed images for use in this book.

INTRODUCTION

Oklahoma State University, formerly known as Oklahoma Agricultural & Mechanical College (OAMC), was founded based on the Morrill Land-Grant Acts that allowed for the creation of land-grant colleges. The Morrill Land-Grant Acts states that it is "an act donating public lands to the several States and [Territories] which may provide colleges for the benefit of agriculture and the mechanic arts." It also states "that there be granted . . . an amount of public land, to be apportioned to each State a quantity equal to thirty thousand acres for each senator and representative in Congress to which the States are respectively entitled by the apportionment under the census of eighteen hundred and sixty." Note that the land-grant colleges did not forgo the other scientific and classical studies or even military regiments but rather just placed a large emphasis on agriculture and the mechanic arts. The 30,000 acres donated to each eligible state could either be used to build the school on top of or to sell for profit to help pay for land and construction of the school elsewhere.

Land-grant colleges through their agricultural experiment stations beginning in 1887 were selected by Congress under the Smith-Lever Act of 1914 to distribute information from agricultural and veterinary research through the cooperative extension to farmers and homemakers in every county in the state.

Stillwater local George W. Gardenhire, the speaker in the Oklahoma Territorial Legislative Council, recognized that securing the placement of the land-grant college and agricultural experiment station would create a stable economic foundation for the community, so he organized area leaders to bring the college to Stillwater. Civic leaders in Stillwater agreed to meet the legislative requirements of donating an 80-acre site and $10,000 to support the construction of a college building. A tract of land on the north boundary in the northwest portion of Stillwater, owned by Alfred N. Jarrell and Frank E. Duck, was selected. In addition, adjacent landowners Oscar M. Morse and Charles A. Vreeland agreed to make more land available. On July 11, 1891, Stillwater offered the territorial commission a prairie virgin site of 200 acres and $10,000 in bond financing. The territorial commission accepted the Stillwater offer over those from other communities, including Perkins.

James C. Neal was appointed director of the agricultural experiment station in August 1891 and selected the site for the agricultural experiment station and college campus. In the spring of 1892, early construction on the campus included that of a two-story barn, station laboratory, and houses for the farm superintendent and the president of the college. In 1893–1894, Frank A. Waugh, the school's first professor of landscape design, worked with Neal in preparing a site plan for the campus. To create the layout of the campus and agricultural experiment station, a site plan was prepared showing the location of proposed buildings and roads. The plan was prepared and implemented and started a practice by the college of using master plans to guide campus development.

After examining two sites, the board of regents decided to locate the College Building, now known as Old Central, 120 feet from the southern boundary between the campus and the community. (Please note going forward in the book that the College Building will be referred to by its present-day name of Old Central to avoid any possible confusion.) In June 1893, the board of regents retained Herman M. Hadley, an architect form Topeka, Kansas, to design Old Central, the first permanent building on the campus.

Initially, the college was organized into departments to teach agriculture, engineering, and domestic science. Over time, the college added more programs to each department. Eventually, departments for the arts and science and business were added.

By the 1920s, OAMC had grown to occupy 80 of the original 200-acre allotment with over 20 buildings. Twelve of these facilities were considered major buildings, and the others were classified as minor buildings, which were mostly wood-frame construction at the agricultural experiment station. The agricultural experiment station farmland increased to 940 acres.

By mid-century, OAMC had a statewide presence with five campuses and a public educational system established to improve the lives of people in Oklahoma, the nation, and the world by adhering to its land-grant mission of high-quality teaching, research, and outreach. Its research, scholarship, and creative activities promoted human and economic development through the expansion of knowledge and its application.

On July 1, 1957, Oklahoma A&M College (OAMC) became Oklahoma State University (OSU), with a statewide presence on five campuses and a millennium enrollment of 35,000 students and a land-grant mission of high-quality teaching, research, and outreach. OSU and its nine different colleges offer more than 350 undergraduate and graduate degrees and options, as well as professional degree programs in medicine and veterinary medicine. Students are enrolled from all 50 states and nearly 120 nations. OSU has more than 200,000 OSU alumni throughout the world.

The main campus is OSU-Stillwater, with other campuses include OSU-Tulsa; OSU Center for Health Sciences in Tulsa, which includes the OSU Medical Center; OSU-Oklahoma City; and the OSU Institute of Technology in Okmulgee. In addition, OSU operates 16 agricultural experiment stations statewide, extension offices in 76 counties, a new sensor-testing facility in Ponca City, and a biosciences institute in Ardmore in partnership with the Noble Foundation. OSU areas of emphasis include animal based agriculture and biotechnology; food production and safety; transportation and infrastructure; sensors and sensor technologies; environmental protection; alternative energies and conservation; manufacturing and advanced materials; health and medicine; and national defense and homeland security.

Starting in the 1960s, OSU graduates working with Oklahoma professional design offices in architecture, landscape architecture, and engineering began contributing their skills to the planning and designing the campus. Landscape architecture graduates were involved in creating landscape master plans that enhanced and beautified the campus through the use of sustainable principles in the excellent selection of plant material and design features in such projects as Theta Pond, formal gardens on the mall, Monroe Street pedestrian walkway, Legacy Walk on the east-west axis, Oklahoma State Student Union Plaza, and an irrigation system for the campus. Architecture graduates were involved in the design of the Wes Watkins Center, Bellmon Research Building, Spears School of Business Building, Intermodal Transportation Center, expansion of Gallagher-Iba Arena, Boone Pickens Stadium expansion, renovation of Oklahoma State Student Union, and parking garages. Engineers designed and developed the infrastructure of the campus's roadways, water, sanitary and storm water sewer systems, and outdoor lighting system.

One

PRAIRIE VICTORIAN
1891–1905

James C. Neal was appointed director of the agricultural experiment station in August 1891 and selected the site for the agricultural experiment station and college campus. In the spring of 1892, early construction on the campus included that of a two-story barn, station laboratory, and houses for the farm superintendent and the president of the college.

In 1893–1894, Frank A. Waugh, the school's first professor of landscape design, worked with Neal in preparing a site plan for the campus. Waugh previously worked at Kansas State University; there, he introduced elements of a naturalistic curvilinear design to be used in Kansas State's campus plan, in its road system. OAMC's plan, which was initially developed by Waugh with Neal, resulted in a combination of curvilinear and rectangular design for the campus through a broad curved drive and walk to Old Central.

After examining two sites, the board of regents decided to locate the first permanent structure, Old Central, in the center of the site on a broad U-shaped drive off College Avenue, present-day University Avenue, 120 feet from the southern boundary between the campus and the residential area of the community. (Please note going forward in the book that College Avenue will be referred to by its present-day name of University Avenue to avoid any possible confusion.) In June 1893, the board of regents retained Herman M. Hadley, an architect form Topeka, Kansas, to design Old Central in Prairie Victorian design style with a bell tower, which depicts the Richardsonian Romanesque design, with an arch in distinctive Roman Empire style over the main entrance. Old Central, dedicated in 1894, dominated the early campus.

As the campus developed, the board of regents did not favor one architectural building style over others; however, during this early period, Neo-Gothic design was decided on for the imposing library building. In the early years, almost every building on campus presented a different style.

After two years, Waugh left OAMC to take a faculty position and become head of the second-oldest landscape design program in the United States that later became the Department of Landscape Architecture at the University of Massachusetts; therefore, after his departure the curvilinear design diminished when the campus plan was revised in 1910 by J.D. Walters.

From 1891 to 1905, the major accomplishments were the establishment of the agricultural experiment station and a campus plan and the construction of Old Central, the library, Chemistry Building, Civil Engineering and Gymnasium Building, greenhouse and dairy building, and the athletic courts and fields.

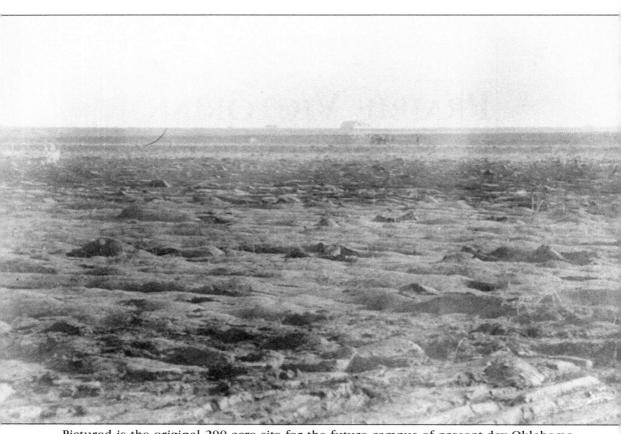

Pictured is the original 200-acre site for the future campus of present-day Oklahoma State University, Stillwater. The land was acquired in 1891. (Courtesy of Oklahoma State University Archives.)

The town of Stillwater in Payne County, Oklahoma, was legally established in 1889; therefore, when the future site of the Oklahoma A&M College was selected in the spring of 1891, most of the property still belonged to the original homesteaders. Portions of four homesteads were transferred to the college's board of regents for the use of the college and agricultural experiment station. A section of the southern portion of the 200-acre tract came from Frank E. Duck, pictured. Duck, as a member of the class of 1896, became one of the first graduates of the college. (Courtesy of Oklahoma State University Archives.)

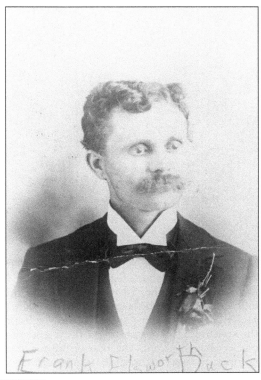

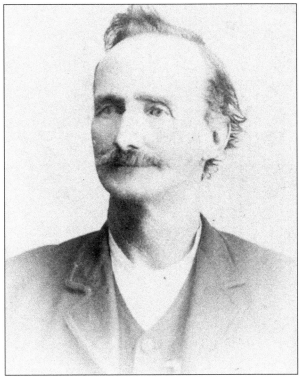

The other section of the southern portion of the 200-acre tract came from Alfred N. Jarrell, pictured. (Courtesy of Oklahoma State University Archives.)

Once the former homestead lands were transferred to the Oklahoma A&M College Board of Regents in November 1891, James C. Neal, the first agricultural experiment station director, led a crew to mark the corners of the 200-acre property and drew the first campus plan. Crops, orchards, and gardens replaced the virgin prairie. Though a wheat trial was established in the southwest corner of the property and ponds were dug, most of the land was set aside as pasture for livestock. The first buildings, which included the director's house, a barn, and laboratory, were located on 10 acres in the southeast corner of the campus. (Courtesy of Oklahoma State University Archives.)

Pictured in the foreground is Old Central, the first permanent structure on campus. It was constructed in 1893 and dedicated in 1894. Today, it is Oklahoma State University's oldest campus building. (Courtesy of Oklahoma State University Archives.)

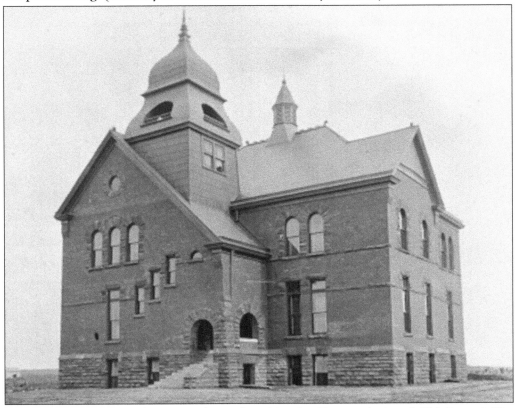

In 1893, Herman M. Hadley, an architect from Topeka, Kansas, designed Old Central. The foliated-metal ornamentation of the roof of the bell tower depicts the overall heaviness of Richardsonian Romanesque style. (Courtesy of Oklahoma State University Archives.)

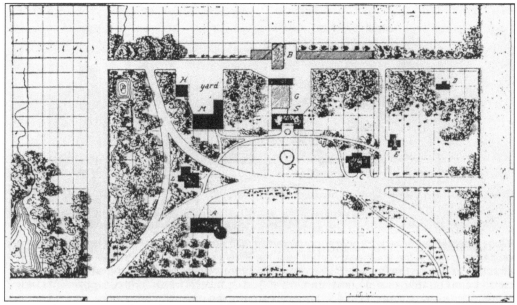

During the 1893–1884 academic year, Prof. Frank A. Waugh with James C. Neal proposed the first plan for the campus. The plan included several new buildings and landscaping for the eight-acre campus. (Courtesy of Oklahoma State University Archives.)

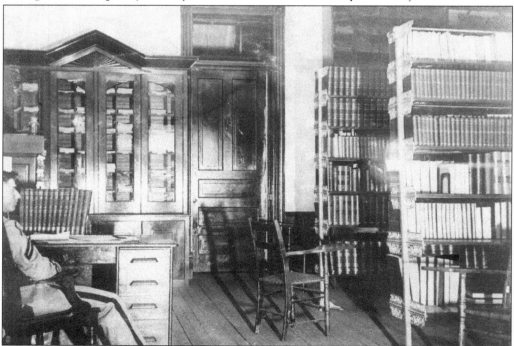

The college's original library was located on the first floor of Old Central. It occupied one side of a room that was also used for English and literature classes. Student George Bowers, wearing an official cadet uniform, is pictured on the left. (Courtesy of Oklahoma State University Archives.)

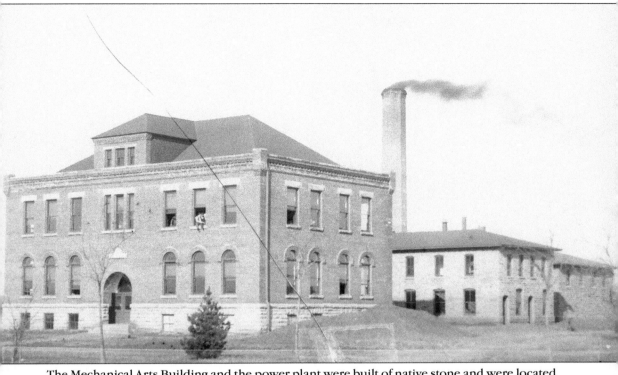

The Mechanical Arts Building and the power plant were built of native stone and were located northwest of Old Central. Due to structural problems caused by the continuous vibrations of mechanical equipment, the Mechanical Arts Building was condemned 12 years after its construction. (Courtesy of Oklahoma State University Archives.)

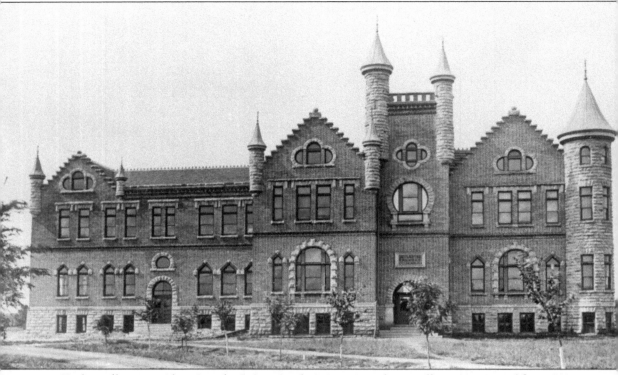

Under college president Angelo C. Scott's administration, the enrollment increased from 219 students in 1898 to 366 in 1899. Joseph P. Foucart, an architect from Guthrie, Oklahoma, who not only designed several commercial buildings in Guthrie but also worked on the Palais Garnier in Paris, France, was retained to design and supervise construction of the new Prairie Gothic Revival–style library building. Native sandstone was used for the base of the building, and a locally produced, smooth-faced brick was used for the American bond upper portion of the structure. The building, named Williams Hall, was completed in November 1900. Besides housing the library on the first floor, the building provided space for classrooms and offices for the languages, history, and economics departments. The second floor housed a zoological museum and several laboratories for zoology and bacteriology. Space for a future addition was reserved on the west side of the library. (Courtesy of Oklahoma State University Archives.)

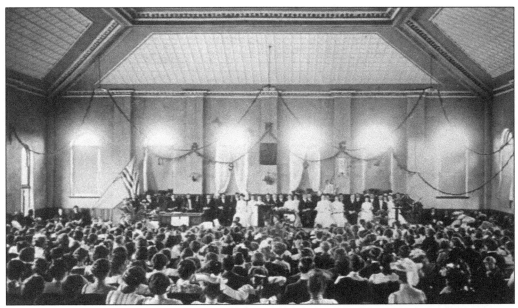

This auditorium, also known as the Prairie Playhouse, was located in Williams Hall Addition. It was initially designed to accommodate 800 people but ultimately could hold 1,200. The auditorium occupied only one floor, but a steeply sloped roof and arched ceiling provided a feeling of openness far greater than the actual area of floor space. The east basement under the original structure was remodeled in 1902 and used as a gymnasium. (Courtesy of Oklahoma State University Archives.)

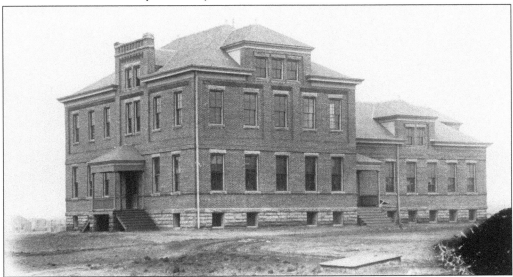

The coming of railroad services to Stillwater in 1900 greatly assisted the procurement and delivery of construction materials to campus. The Chemistry Building was the third major structure to be built on the western edge of the campus in 1900. The building provided academic classrooms in addition to office space for the chemistry department; it also housed the agricultural experiment station laboratory in its north wing. (Courtesy of Oklahoma State University Archives.)

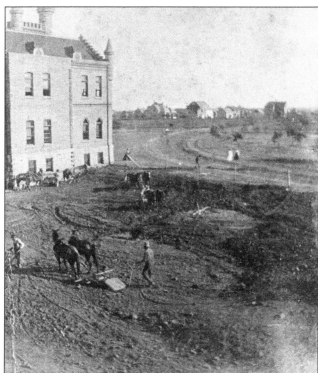

Joseph Foucart was retained to design the Prairie Gothic–style addition to the west side of the Williams Hall. The expansion provided more classrooms, a laboratory, offices for the biological and domestic sciences, and a 1,200-person auditorium for religious services, assemblies, plays, and a variety of other activities. The addition was completed in 1902. (Courtesy of Oklahoma State University Archives.)

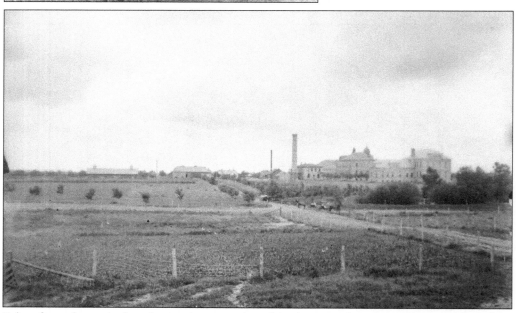

Taken from the agricultural experiment station, this photograph captures the rural feel of the early campus. Note the horse-drawn carriages along Washington Street. Buildings include, from left to right, the first horticulture building, the first college barn, the veterinary laboratory, the power plant and smokestack, Prairie Playhouse, the 1902 engineering building, and the Chemistry Building. (Courtesy of Oklahoma State University Archives.)

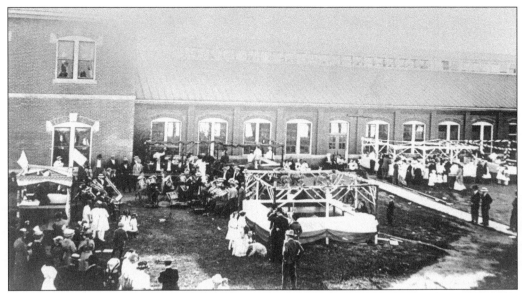

The Civil Engineering and Gymnasium Building, completed in 1905, was located on the site of the old wooden college barn, the first campus facility, which was moved to a new location. The crowds at the annual harvest carnival enjoyed a football game, music, games of chance, athletic contests of speed and strength, and a reunion with old friends. (Courtesy of Oklahoma State University Archives.)

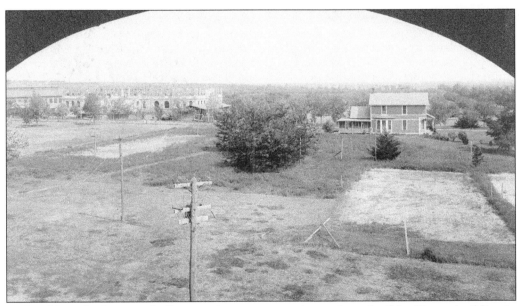

Early athletic facilities, including tennis courts, were located north of the library building in 1906. These facilities were used mostly for intramural sports and physical education classes. Morrill Hall, pictured in the upper-left corner, is under construction on the former site of the college vineyard. The agricultural experiment station director's house on the right was converted to offices and classrooms. (Courtesy of Oklahoma State University Archives.)

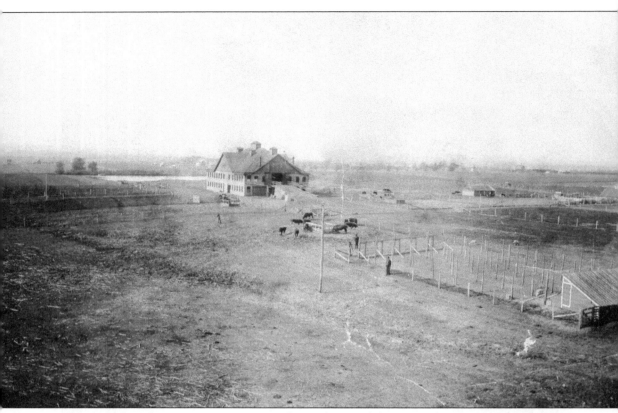

The agricultural experiment station was located west of the original campus. In 1902, a two-story brick barn was completed to house livestock and agricultural implements. For animals and equipment to reach the second story, there were large earthen ramps on the north and south sides. The livestock holding pens surrounded the barn and pond.

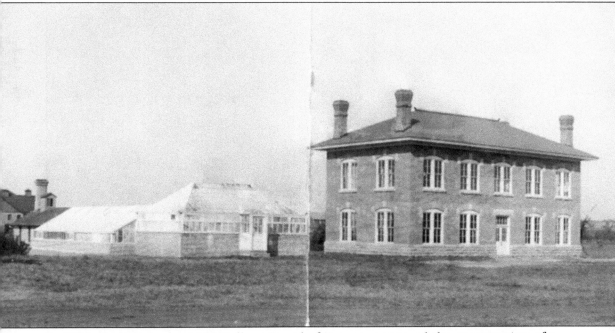

In 1904, the Oklahoma A&M College Board of Regents approved the construction of a greenhouse and a dairy building. Later, the west end of the dairy building was expanded to increase the capacity of the creamery, which was a popular place among students and teachers for ice cream.

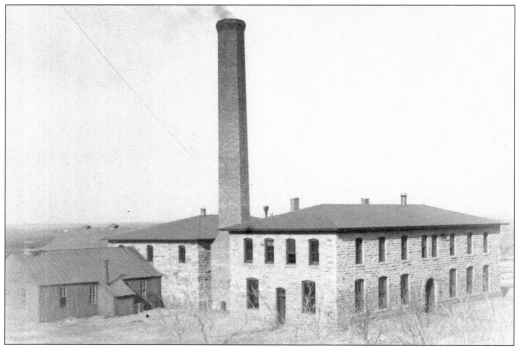

The first power plant and Mechanical Arts Building, constructed using native stone, were located northwest of Old Central.

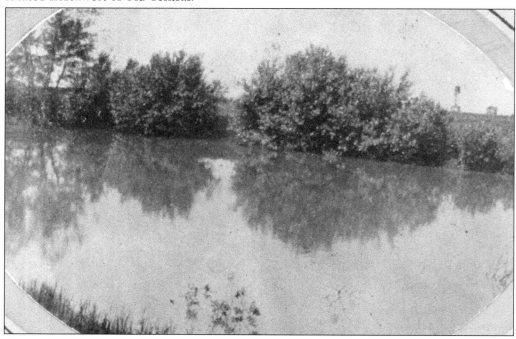

Willow Pond provided the first surface water at the college, since securing a dependable source of water during the first decades of the college and agricultural experiment station proved difficult.

Two

GOTHIC REVIVAL PERIOD
1906–1919

President Scott understood the influence of Justin S. Morrill, author of the land-grant acts, and felt every land-grant college should have a facility named after Morrill. Scott was successful in securing funds to build Morrill Hall, the last facility to be funded during the territorial period.

Statehood for Oklahoma brought dramatic changes to the campus of Oklahoma Agricultural & Mechanical College (OAMC) as Indian and Oklahoma Territories were merged into one state. As a result of this change, the enrollment doubled between 1906 and 1910 when the college began attracting students from outside of Stillwater and Payne County. The mission of OAMC was to equip its graduates with the necessary skills to fill the roles in agriculture, teaching, engineering, and domestic science.

During the summer of 1910, the college retained J.D. Walters, landscape designer on the faculty of Kansas State University, in Manhattan, Kansas, to prepare a campus plan. Walters updated the earlier plan prepared by Frank A. Waugh by formalizing the curved entrance road into a formal U-shaped entrance road, which maintained a sympathetic relationship with the Stillwater rectilinear street system in the layout of future roads and buildings on the campus and established a center line or axis through campus. This rectilinear concept influenced the development of the highly influential 25-year Beaux-Arts, Neo-Georgian campus plan under Pres. Henry G. Bennett's administration.

During this period, OAMC had grown to 80 acres with over 20 buildings. Twelve of these facilities were considered major buildings, and the others were classified as minor, which were mostly wood-frame construction at the agricultural experiment station. The agricultural experiment station farmland increased to 940 acres.

The major accomplishments of J.D. Walters's campus plan included the construction of Morrill Hall, a boys' dormitory (Crutchfield Hall), stock judging pavilion, auditorium building (nicknamed "the chapel"), a new power plant, new engineering building (Gundersen Hall), a hog barn, dairy barn, football stadium and Lewis Field, the President's House, an armory-gymnasium, and a new science building.

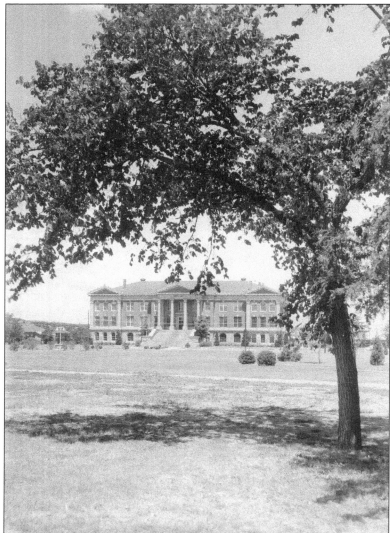

Prior to statehood in 1907, Morrill Hall was completed in 1906. The building was named after Justin S. Morrill, the founder of the land-grant acts for the establishment of an applied arts and agricultural college in each state. The design of the building introduced the Neoclassical style to the campus, which complemented the early formal layout of the grounds. (Courtesy of Oklahoma State University Archives.)

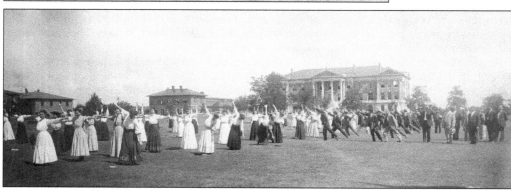

Here, on the lawn in front of Morrill Hall, students celebrate Oklahoma being granted statehood. (Courtesy of Oklahoma State University Archives.)

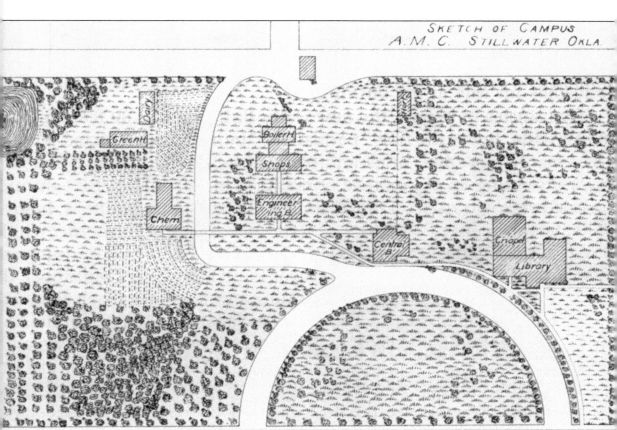

A sketch of the campus was prepared by Harry G. Hoke for a class project in 1904. The plan called for making a U-shaped road off University Avenue to the front of the library and Old Central and back to University Avenue, with an access road to the chemistry and engineering buildings, shop, dairy, and greenhouse to the north with a connection to an east-west road. The central building is the only building that has survived. (Courtesy of Oklahoma State University Archives.)

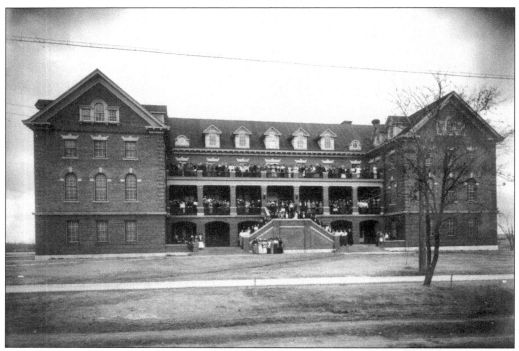

The Domestic Science Building was a four-story multifunctional facility. The first floor contained a dining room on one side and a gymnasium on the other side. Along with the second floor, the first floor also contained classrooms, kitchens and laboratories, and a few offices with a room for the women's matron. The third and fourth floors served as a residence hall for female students.

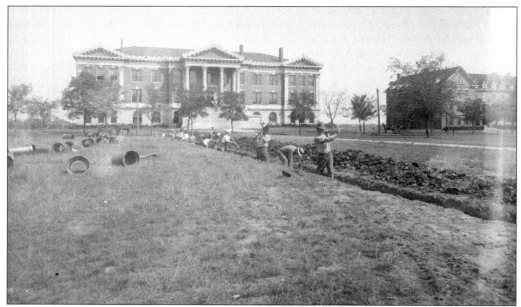

To accommodate the continued expansion of campus, sewer and electrical lines were laid to serve new construction on the campus. The work was completed using manual labor.

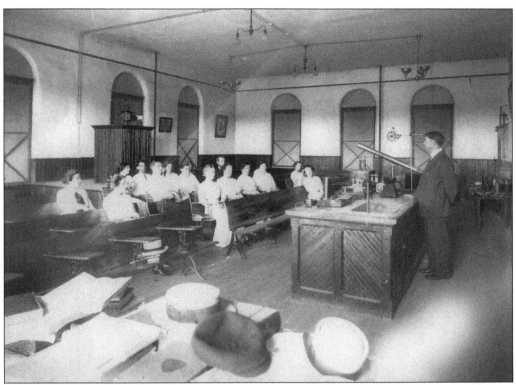

The educational philosophy of land-grant colleges went beyond lectures in the classroom to provide students with practical skills learned through participation. Lectures were given in all the subjects, but in some of the disciplines, such as agriculture, mechanical arts, and the domestic sciences, the amount of time spent in classrooms was matched with hands-on experience at field stations, shops, laboratories, and kitchens.

Following statehood in 1907, J.D. Walters, landscape architect, proposed a campus plan based on continuing the Stillwater rectilinear street system layout. This plan (pictured) influenced the development of the campus under Henry G. Bennett's administration. (Courtesy of Oklahoma State University Archives.)

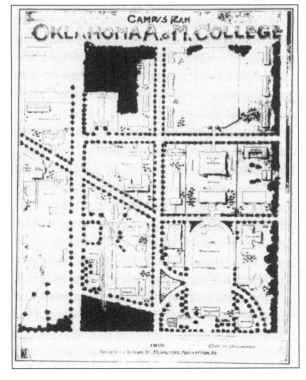

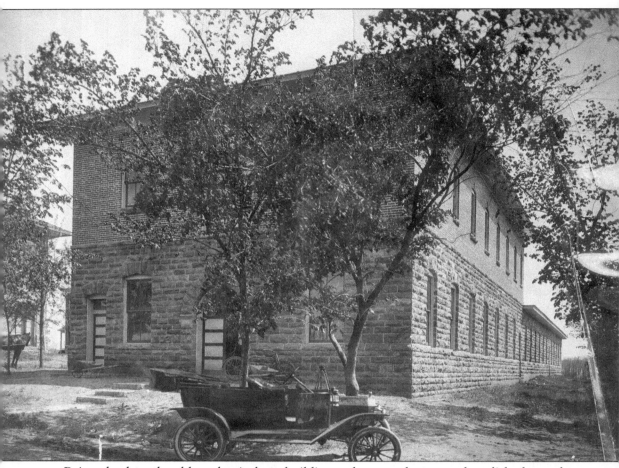

Being obsolete, the old mechanical arts building and power plant were demolished to make way for the new engineering building in 1911. The building's native stone was salvaged and reused to construct a shop building by the mechanical arts department, located south of the power plant. (Courtesy of Oklahoma State University Archives.)

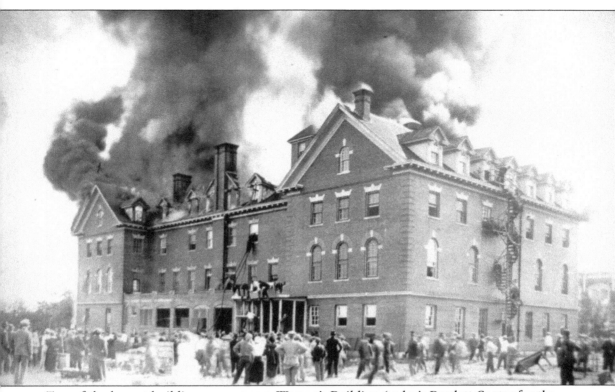

Two of the largest buildings on campus, Women's Building (today's Bartlett Center for the Studio Arts) and Morrill Hall, were severely damaged by fires, which threatened the relocation of the college from Stillwater. A large crowd was at the Women's Building to enjoy harvest carnival festivities in October when the upper floors of the building were heavily damage by a fire; this event occurred a few months after a fire gutted the interior of Morrill Hall in August. Fortunately, no one was injured in either fire. Both buildings were restored, although Morrill Hall lost some of its original architectural features.

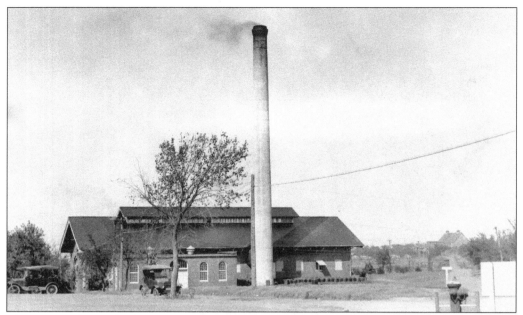

The power plant, which was completed in 1912, served the power and heating needs of the campus for the next 50 years. The existing tunnels were connected to the new centralized heating and electrical systems and expanded to new buildings, thereby creating a maze of tunnels throughout the campus. (Courtesy of Oklahoma State University Archives.)

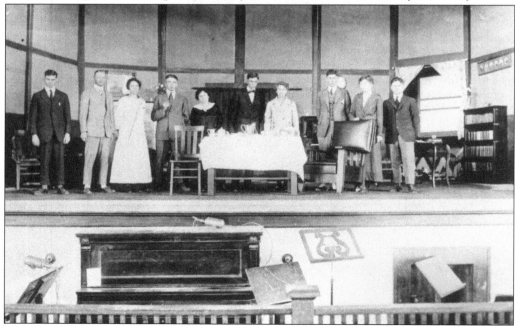

The auditorium, with a stage and orchestra pit, was completed in the fall of 1912 and was small by current standards. It was adequate for most productions of the time. The raised stage for the actors and recessed floor for the musicians provided excellent views of the activities for the patrons of the performing arts.

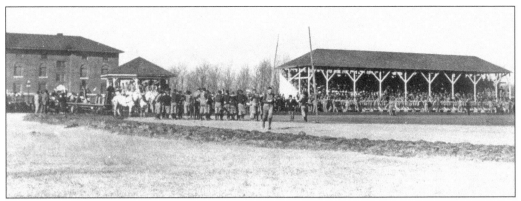

The west side of Lewis Field had a covered grandstand and a gazebo for a band. These facilities provided protection from the elements. Since seating was limited, many spectators viewed the games from their parked vehicles on the east side of the field.

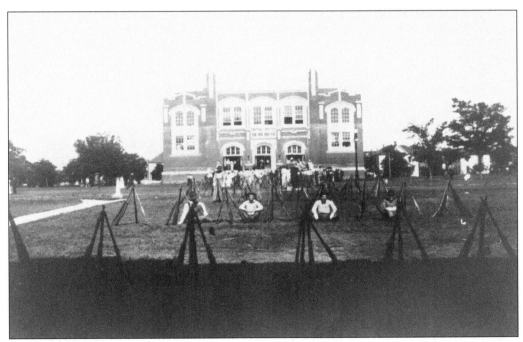

Hundreds of Oklahoma A&M College men volunteered for military service during World War I. The campus served as the site for the Student Army Training Corps until the end of the war. Part of the training occurred on the parade ground north of Gunderson Hall (the civil engineering building), Morrill Hall, and the Women's Building (shown here).

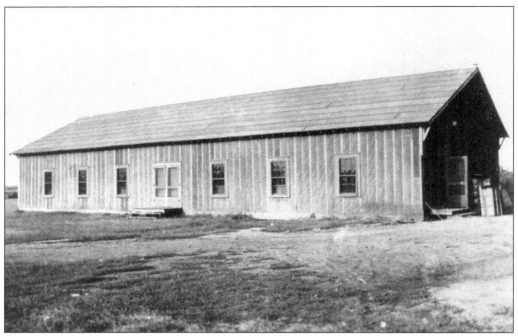

In 1918, the old stock judging pavilion was converted into a dormitory for the Student Army Training Corps cadets. The vocational training department constructed a new dining hall north of the Women's Building, which provided additional seating close to the nearby domestic science kitchens. The structure was demolished a few years after it was erected.

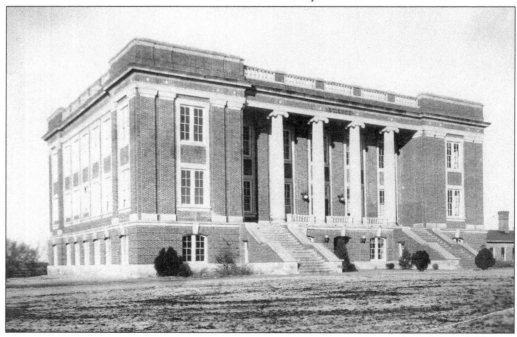

The two-story science building, designed in a Neoclassical style by Frederick W. Redlich, was located off University Avenue west of Old Central.

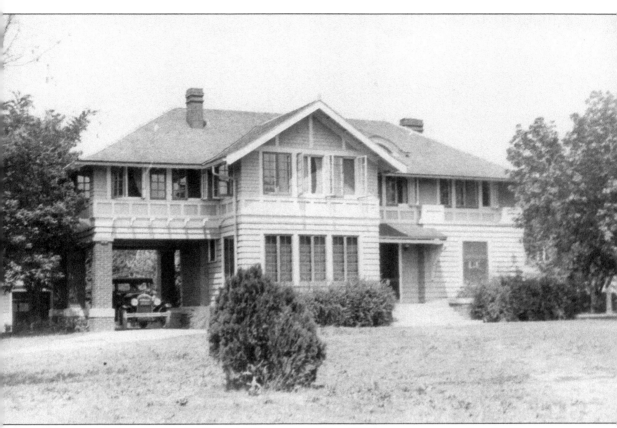

The President's House, built in 1917, was razed in 1952 to create a site for the Bennett Memorial Chapel. The white wood-frame house was the site of numerous teas, receptions, and meetings for thousands of students, faculty, and staff.

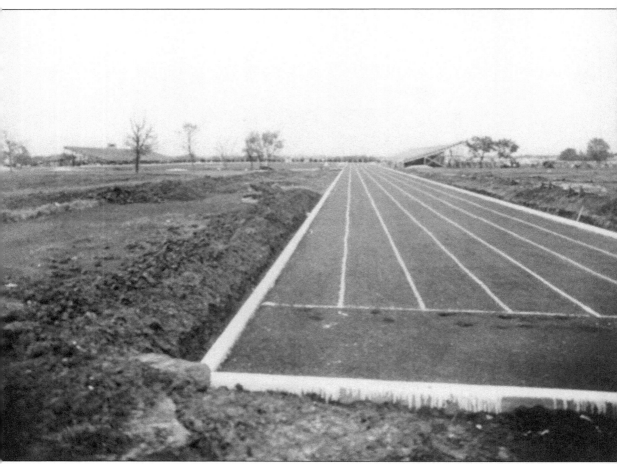

In 1913, Oklahoma State University, then known as Oklahoma A&M, began a football team. It played at the current site of Pickens Stadium, then with a traditional north-south orientation, which was later converted to an east-west orientation to avoid strong prevailing winds that resulted in the team defending the east goal having to look directly into the bright sunlight. Originally known simply as Athletic Field, with an 8,000-seat grandstand capacity, it was renamed Lewis Field in 1914, after Laymon Lewis, former dean of veterinary medicine and of science and literature.

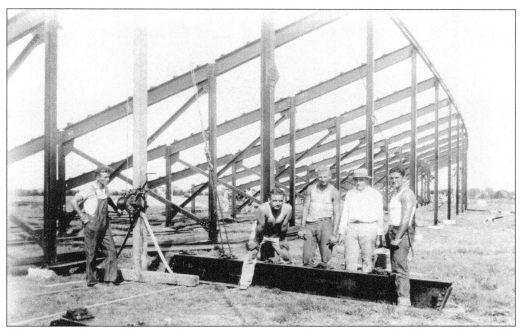

The Lewis Field Track was built as a 220-yard straightaway track, which started near the present-day Cordell Hall and ended near the present-day Gallagher-Iba Arena.

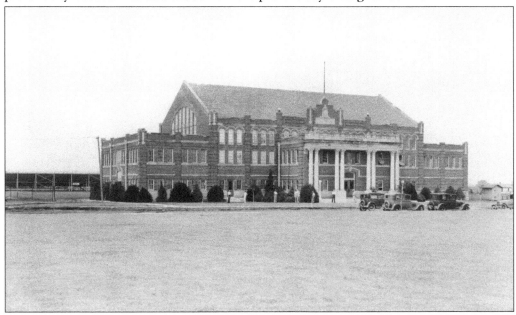

An agreement to use the armory-gymnasium as a training center for the Student Army Training Corps resulted in the college procuring steel during the period of war rationing. After its completion in 1919, at the end of the war, it served principally as a gymnasium and was the site of the very successful programs under Edward C. Gallagher for wrestling and Henry P. Iba for basketball over the next 20 years. Frederick W. Redlich, head of the School of Architecture, is credited for designing the building.

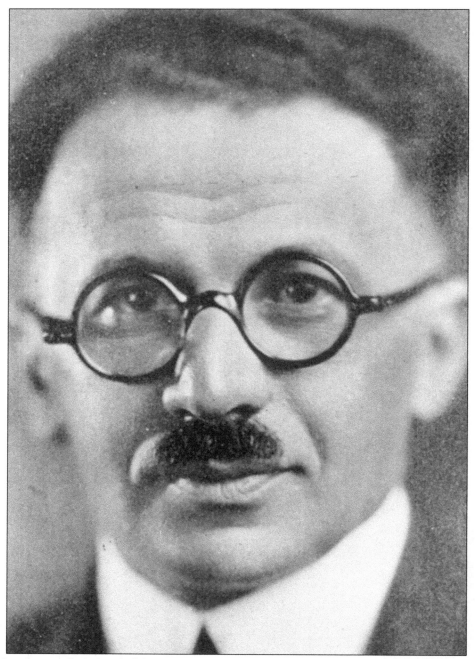

Frederick W. Redlich, head of the Department of Architecture, designed the armory-gymnasium, which was completed in 1919. The facility served in several capacities. In accordance with the US government contract, it served as a training center for the Student Army Training Corps, which permitted the college to procure steel during the war. The gymnasium served as the athletic center for indoor sports for nearly 20 years. It also served as the site where Henry P. Iba coached a very successful basketball program and Edward C. Gallagher developed an equally successful wrestling program.

Three

NEOCLASSICAL PERIOD
1920–1929

J.D. Walters's campus plan with its formal layout continued to be implemented during this period, which was complemented with the use of Neoclassical details on buildings, such as the new science building and the animal husbandry building. These Neoclassical details strengthened the presence of the Neoclassical architectural design style on the campus.

By the end of the 1920s, campus facilities occupied 120 acres of the original 200-acre allotment. During this decade, limited attempts were made to bring together architectural features and materials such as the use of white limestone and brick and Neoclassical design features such as columns and decorative urns along rooflines of various buildings.

When Dr. Henry G. Bennett became president on June 1, 1928, he quickly started planning for the future and appointed a campus planning committee to develop a vision for OAMC in the form of a model to show the legislature and the public the proposed growth of the campus for the next 25 years. The board of agriculture authorized the president to employ the planning firm McCrary, Culley & Carhart of Denver, who had planned several colleges in the West and Midwest, to prepare a plan for the campus, showing the layout of roads and buildings but not the landscape. Bennett was not satisfied with the proposed plan and requested Professors Wilber and Hamilton to review and revise the plan, which was presented and approved by the board on October 6, 1930. The Neo-Georgian style of architecture with red brick, beige-stone trim, and slate roofs with dormer windows was chosen as the architectural style for the improved campus.

The campus began to evolve into a modern institution under the guidance of J.D. Walter's campus plan.

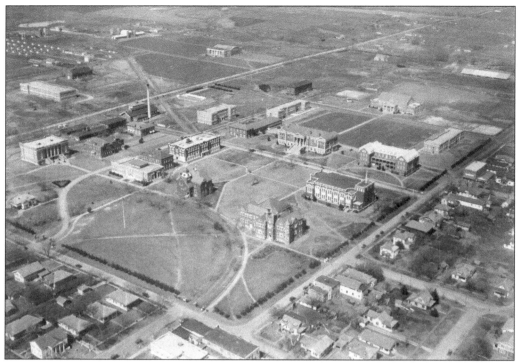

The campus in the 1920s had grown west and northwest and reached Washington Street (a section line road known at the Albert Pike Highway). The development focused on Morrill Hall. Very few buildings were constructed west of Washington Street. The majority of buildings were located around Morrill Hall, with sidewalks leading to these buildings. A memorial fountain dedicated to the class of 1922 was located in the center of the quadrangle in front of Morrill Hall. (Courtesy of Oklahoma State University Archives.)

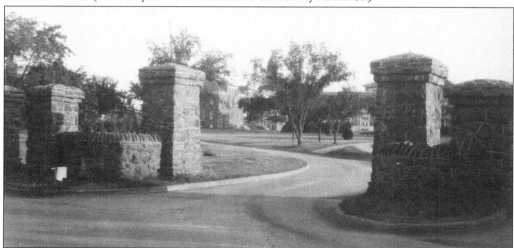

To define the boundary and principal entry points, columns were placed along the eastern and southern edges of the campus. These elaborate entries delineated the edge of city and college streets. Native stone was used in the construction of the monuments, which stood for many years at the Hester Street entrance off University Avenue.

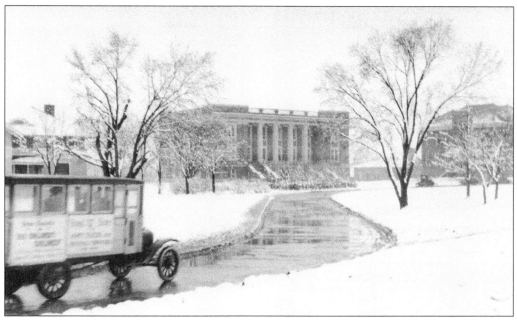

New Science Hall, designed by J.J. Patterson, an architecture faculty member, was completed in 1920 to expand the teaching facilities, which had outgrown the first Chemistry Building occupied in 1899. The new facility greatly expanded its scope and capabilities as well as other related departments. Shown to the left of the hall is the new house for the college president. (Courtesy of Oklahoma State University Archives.)

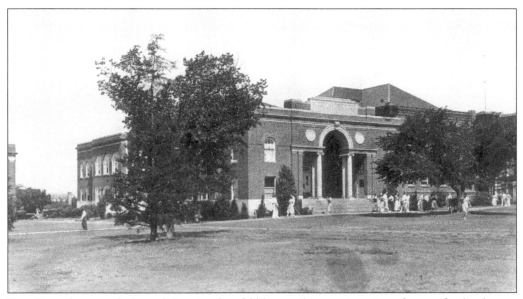

To relieve the crowded conditions in the old library, the construction of a new facility began in 1920. A design team in the architecture department chose an Italian Renaissance design theme. Kreipke-Schaefer Construction Company was selected as the major contractor.

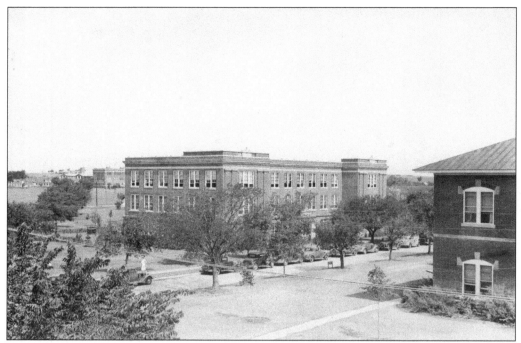

The new home economics building, completed in 1920, was considered one of the most modern facilities of its kind. Dean Ruth Michaels contributed to the design of the facility. The move of the domestic science offices and classrooms to the new building permitted the space it occupied in the Women's Building to be remodeled for additional student residents.

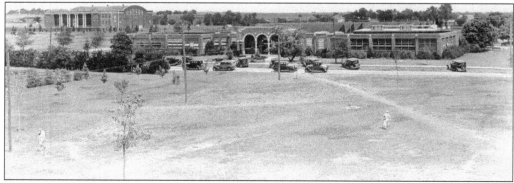

The one-story industrial arts building was designed with the assistance of DeWitt T. Hunt, department head of the industrial engineering department. It featured a sawtoothed roof to provide additional lighting and a thick concrete floor to support heavy machinery typical of shops. It was constructed by the Tankersley Construction Company of Oklahoma City in 1927.

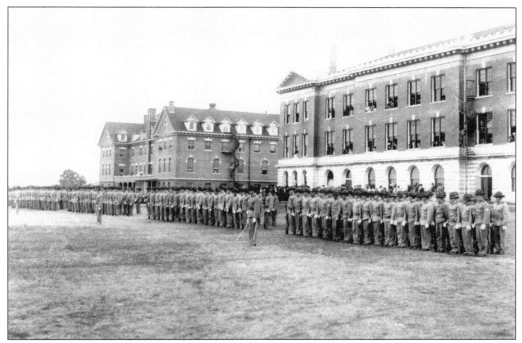

Volunteer cadet training was an important activity on the campus.

. Here, cadets practice drills with firearms on campus.

High-jumping was conducted at the Lewis Stadium track field.

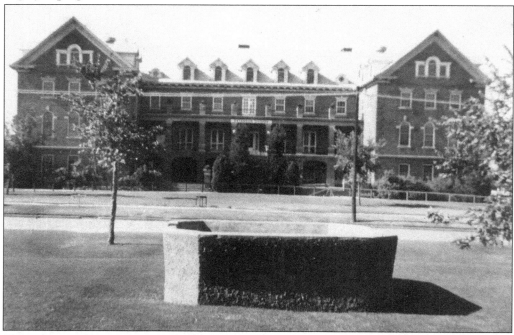

Class memorials were important features in the early years of the Oklahoma A&M College. The octagonal concrete sculpture, pictured in 1925, was a gift to the school from the class of 1917. It was located in front of the Women's Building (today's Bartlett Center for the Studio Arts).

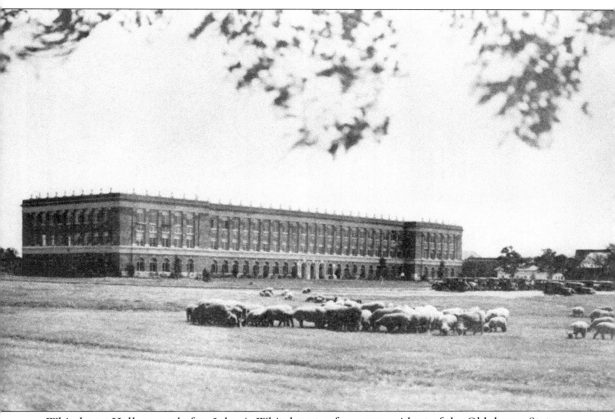

Whitehurst Hall, named after John A. Whitehurst, a former president of the Oklahoma State Board of Agriculture, became the new center of the campus to the west of the original campus quadrangle. The building greatly improved the availability of laboratory, office, and classroom space on the campus. Since it was off-center from the original campus, there were complaints that the building was too far from the rest of the college's buildings.

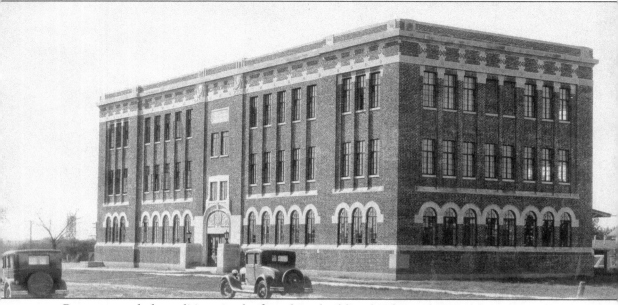

Due to crowded conditions in the first dairy building by the mid-1920s, department head Arthur C. Baer designed and constructed a new dairy building, creamery, and laboratory facilities on the northwest corner of the campus in proximity to the dairy barn. The building featured intricately carved stone details at the entrance to the building and was the last building to be built before the Neo-Georgian architectural style was adopted by President Bennett's administration.

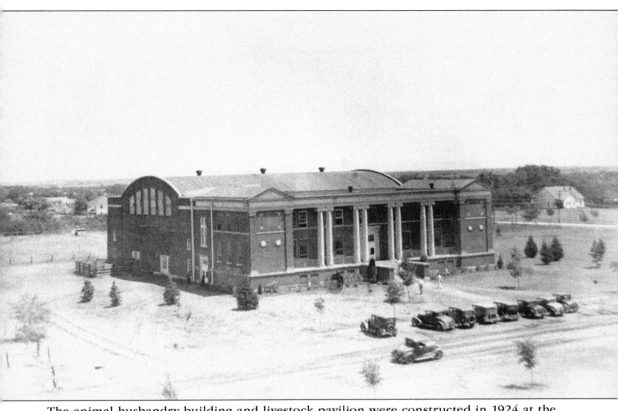

The animal husbandry building and livestock pavilion were constructed in 1924 at the northwest corner of the campus during Pres. Bradford Knapp's administration. The building provided offices, laboratories, and classrooms in the south portion of the structure and a livestock arena in the north section. The building proved popular and was at full capacity for the Little International Stock Show.

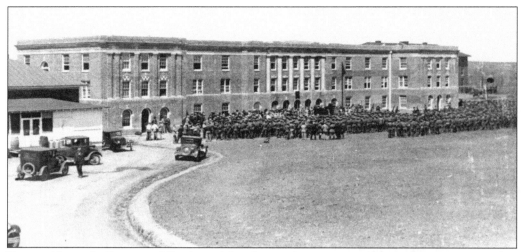

Two residence halls, named for Jessie Thatcher and Carter C. Hanner, were constructed in 1925 to relieve the need for on-campus student housing. The halls were mirror images of each other, with Thatcher for women and Hanner (pictured) for men.

Thatcher Hall offered comfortable steam-heated rooms for women. Each bedroom had two Murphy beds, a study table and chairs, bookracks, and dressers.

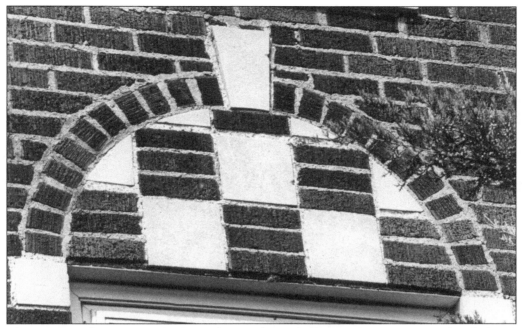

The semicircular brickwork above the residence halls' windows was very detailed and arranged in a checkerboard pattern.

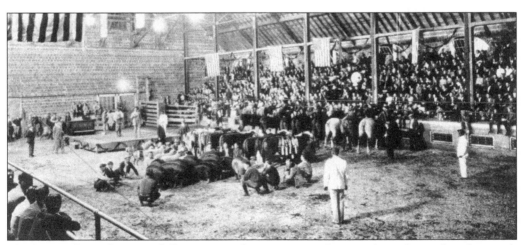

The livestock pavilion was fully connected to campus utilities and was located in the north section of the animal husbandry building. The judging activities in the pavilion drew large crowds.

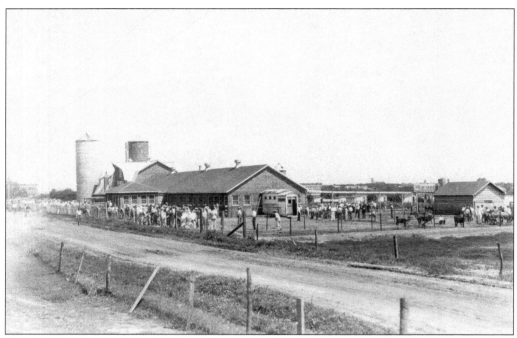

The dairy barn was constructed along Farm Road on the site where the 1920 farmers' field day event was hosted. The dairy barn served the extension program of the college and provided storage for hay for various herds of livestock.

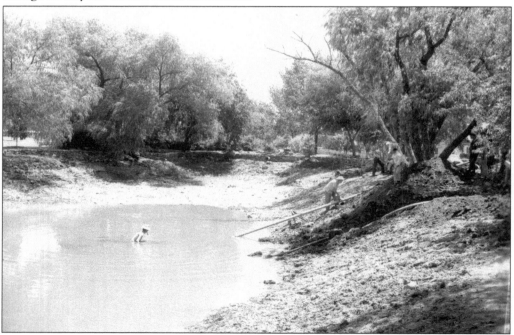

The stock watering pond on the southwest corner of the campus near the present-day intersection of University Avenue and Monroe Street was later converted to an ornamental water feature in a parklike setting and is present-day Theta Pond.

Four

NEO-GEORGIAN PERIOD
1930–1959

Implementation of the 25-year campus master plan began under President Bennett in association with Professor Wilber. Wilber served in a dual responsibility as both head of the architecture program and campus architect. Bryan Thompson joined Wilber and assisted him in developing the landscape design and also served as landscape manager for the campus.

The master plan called for a new campus to be located west of Washington Street; it would have the School of Agriculture and Home Economics, along with a science building, administration building, infirmary, armory-gymnasium, and dormitories for women. The old campus on the east side of Washington Street would be the location of the Schools of Engineering and Commerce and Education, the student union, a gymnasium, and athletic areas, along with dormitories for men. The northeastern portion of campus would remain dedicated to athletics, with a stadium, field house, and playing fields. The plan proposed separate academic buildings for English, languages, poultry, mathematics, botany/horticulture, and aeronautical education, as well as a new power plant on the northwest side of the campus. Old Central would become a museum.

The master plan called for the new library to be positioned as the centerpiece of the cruciform-shaped campus plan. It was to be on an elevated terrace in the center of the campus. The library would be surrounded by about 50 major academic buildings, and 25 of those would be new.

In contrast to past building practices, the master plan called for providing architecture unity to the campus through design, scale, and building materials for all new structures; however, no landscape plan for walkways, site features, and plants was prepared to reinforce the formal layout of the campus. The Neo-Georgian style of architectural design of the Beaux-Arts period, as reflected in the earlier design of Whitehurst Hall, was chosen for all new buildings with brown-orange (terra-cotta-colored) brick called the OSU brick (made in Oklahoma City), limestone trim, and slate roofs with dormer windows.

During this period, changes continued to be made to the site plan of the campus. It was decided to retain the stock watering pond at the corner of University Avenue and Monroe Street by converting it into a minipark with the pond. This landscape feature prevented the complete build-out of the Willard Hall quadrangle. The great lawns (malls) envisioned north and south of the library were disrupted by placing the power plant at the end of the north lawn on what is now Hall of Fame Avenue; the placement of the power plant blocked the view to and from of the library on Washington Street.

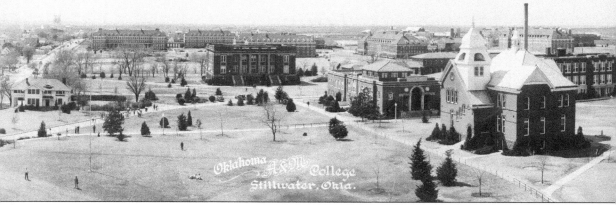

This panoramic photograph is an aerial view of the old campus. The photographer took this image, with a view looking northeast toward the new campus, from the southeastern

William H. Murray, also known as "Alfalfa Bill," championed the values of rural citizens. Murray had a special relationship to the students at the agricultural college in Stillwater. As governor, he approved pioneering legislation that provided for the building of dormitories from the proceeds of self-liquidating revenue bonds. (Courtesy of Oklahoma State University Archives.)

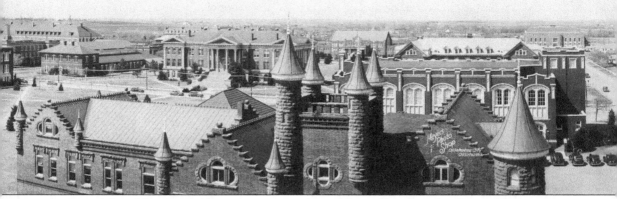

section of the old campus. The new campus was on based on the Neo-Georgian campus master plan.

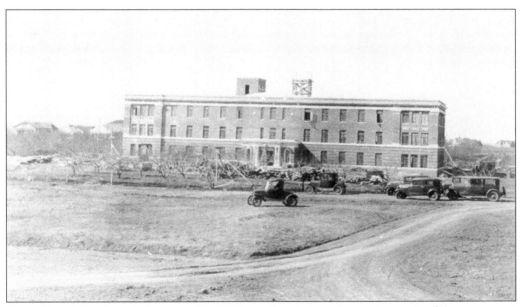

The college's first hospital, opened in 1930, was located on the western side of the campus at the site of a former orchard. Its medical staff consisted of Dr. Katherine Bergegrun, the physician for women; Dr. R.J. Shull, the physician for men; and Dr. H.B. Sherrod, the dentist.

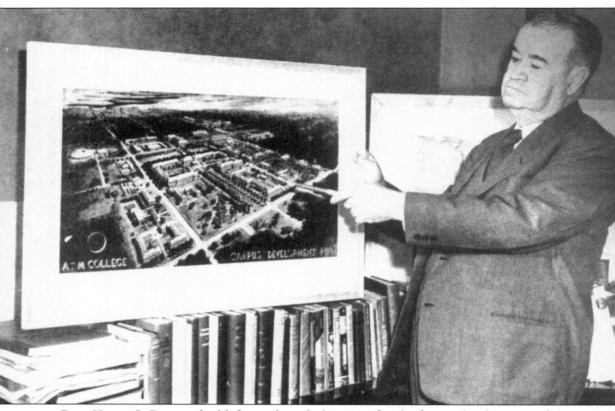

Pres. Henry G. Bennett had lofty goals and objectives for the future development of the campus. He was a visionary and a determined administrator who strived to bring orderly development to the campus through a new 25-year master plan, which was implemented between 1928 to 1951.

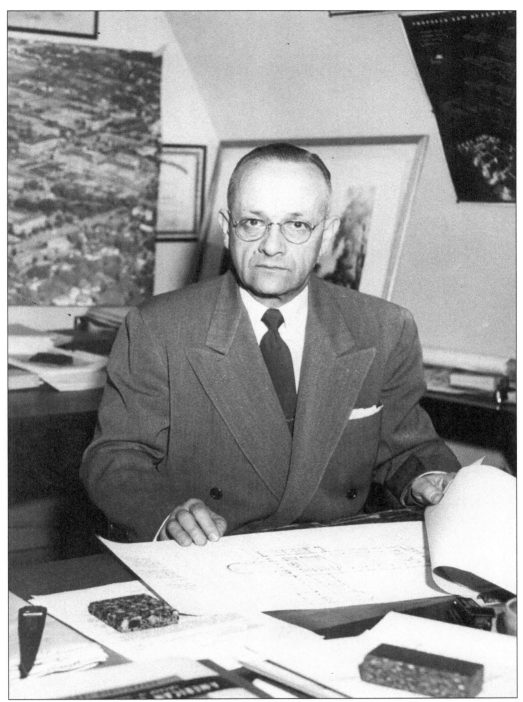

Philip A. Wilber, a member of the class of 1919, directed the planning and development of the campus for over 40 years, starting in 1928. He played a major role in implementing the 25-year campus master plan, in its scale with the actual size of buildings and the amount of financing through bonds needed.

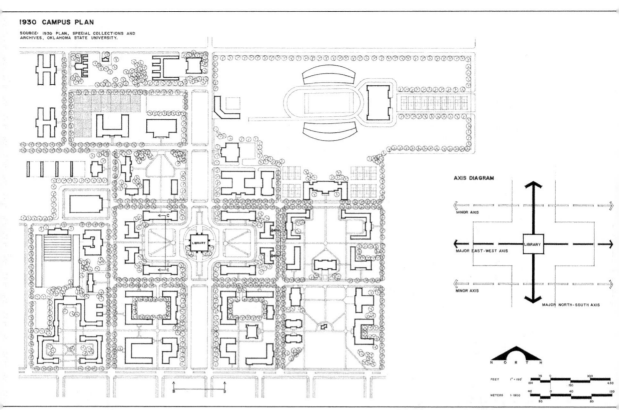

Upon his arrival at Oklahoma A&M in 1928, Pres. Henry G. Bennett advocated the establishment of 25-year plan for campus development. The idea came into fruition in 1928 when the Denver firm McCrary, Culley & Carhart was retained to develop a campus master plan. The firm had been involved in preparing master plans for over 30 colleges in the West and Midwest. A Neo-Georgian design theme, similar to that of Williamsburg, Virginia, that used a terra-cotta build with a bluff-colored limestone trim was the selected. (Courtesy of Library of Congress, HALS Collection.)

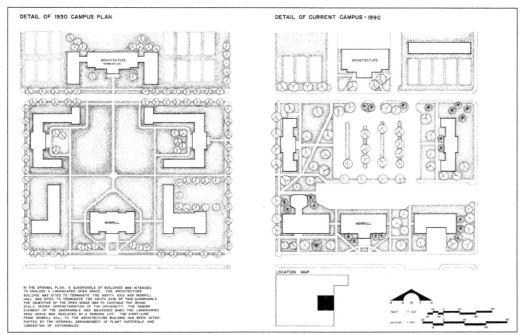

DETAIL OF 1930 CAMPUS PLAN

DETAIL OF CURRENT CAMPUS - 1990

These detailed plans show what the area around the library looked like in the 25-year master plan in 1930 and how it existed at OSU's centennial in 1989. (Courtesy of Library of Congress, HALS Collection.)

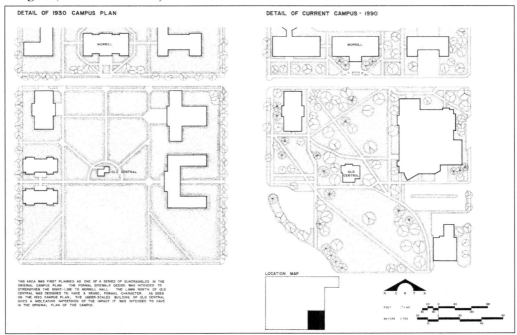

DETAIL OF 1930 CAMPUS PLAN

DETAIL OF CURRENT CAMPUS - 1990

The detailed plan of the old campus around Old Central from the 25-year master plan of 1930 is seen side by side with a diagram of what it looked like in 1989. (Courtesy of Library of Congress, HALS Collection.)

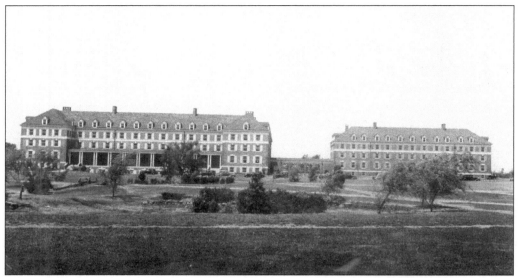

With the increase in enrollment, another residence hall was needed. It was erected adjacent to Murray North Hall, with a covered breezeway connecting the two buildings.

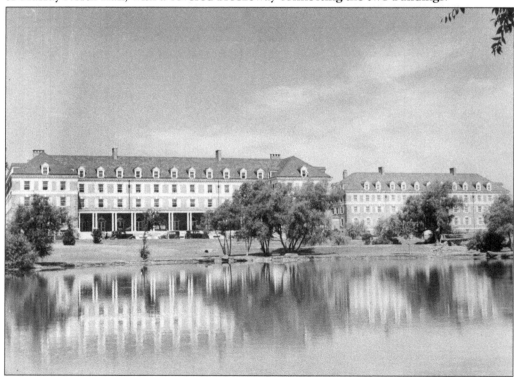

Murray Hall's dormitories confirmed the use of the Neo-Georgian building design style with the OSU blend of brick and beige limestone trim, which became the standard for all future buildings constructed on campus. The dormitories were four stories in height, with a full basement and dormer windows on the top floor. The buildings faced east across Monroe Street toward the popular landmark Theta Pond.

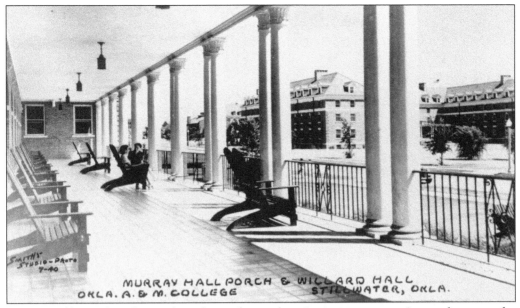

Murray Hall introduced veranda-style porches to dormitories on campus; its porch was on the east side of Murray Hall facing Theta Pond. The porch was graced with handsome columns and a wrought-iron railing and proved a popular place for recreation and socializing for the 410 women residents.

Since the opening of 410-bed Willard Hall dormitory for women, Willard Hall lawn and Theta Pond have been favorite spots for campus activities and for students wishing to share quiet time.

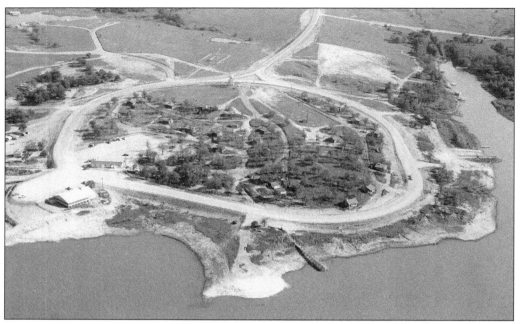

The lake was created for OAMC as a source of water by impounding Stillwater Creek on a 3,000-acre site six miles west of Stillwater. This was done through a federal government program designed to remove badly eroded land from cultivation and convert it to public recreation and other purposes. The recreation area contained rental cabins, boat docking facilities, and picnicking areas.

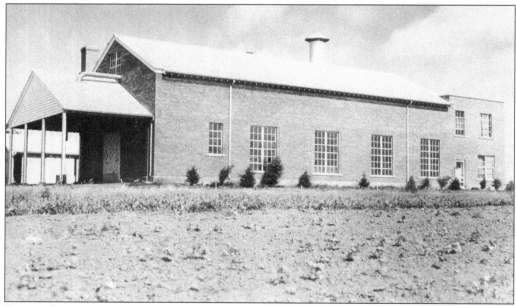

Due to the Great Depression and the economic havoc created by the Dust Bowl, the state and federal governments contributed funds for the construction of a new cotton ginning building. It was hoped that improved ginning procedures would lead to pure seed varieties and ultimately the establishment of one variety of cotton in the state.

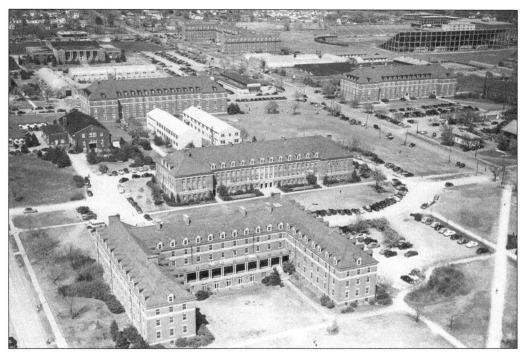

Following the Second World War, Quonsets and temporary frame structures transferred as war surplus still dotted the campus and provided a stark contrast with the traditional brick buildings.

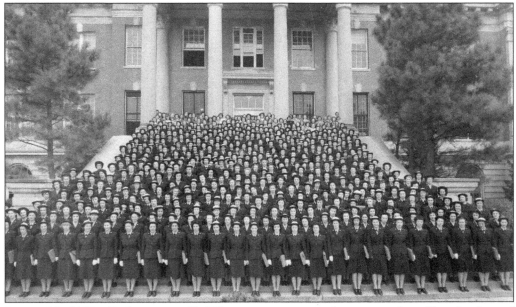

During World War II, there were 10 different programs on the campus that offset the drop of enrollment. In addition, there were thousands of Navy, Army, and Air Corps personnel who studied on the Stillwater campus. The Women Accepted for Volunteer Emergency Service (WAVES) cadets on the steps of Morrill Hall are typical of these military trainees.

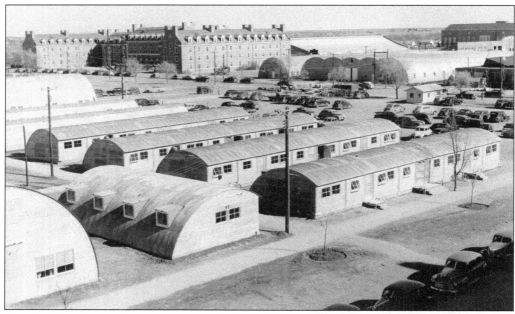

To adjust for the rapid increase in student enrollment at the end of World War II, Quonsets and frame buildings were quickly erected on the main campus, some of which remained until the late 1980s.

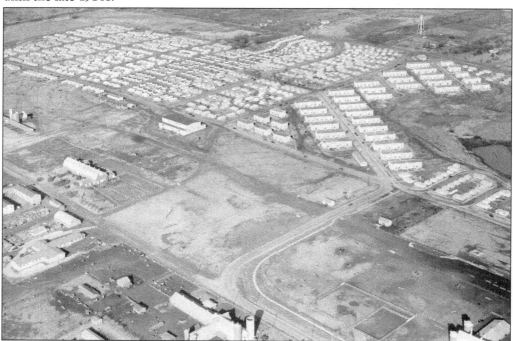

Veterans Village was located on the northwest edge of the campus. It was built to accommodate approximately 4,000 families and was considered one of the largest veterans' campus complexes in the nation. The village provided numerous services to residents, including a "cash and carry" commissary with a wide variety of items.

Bryan Thompson, a member of the 1933 class, directed the design and installation of plant material to make the campus a landscape architecture showplace.

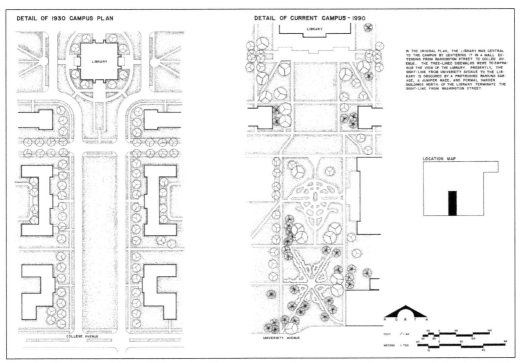

DETAIL OF 1930 CAMPUS PLAN

DETAIL OF CURRENT CAMPUS - 1990

IN THE ORIGINAL PLAN, THE LIBRARY WAS CENTRAL TO THE CAMPUS BY CENTERING IT IN A MALL EXTENDING FROM WASHINGTON STREET TO COLLEG AVENUE. THE TREE-LINED SIDEWALKS WERE TO EMPHASIZE THE VIEW OF THE LIBRARY. PRESENTLY, THE SIGHT-LINE FROM UNIVERSITY AVENUE TO THE LIBRARY IS OBSCURED BY A PROTRUDING PARKING GARAGE, A JUNIPER MAZE, AND FORMAL GARDEN BUILDINGS NORTH OF THE LIBRARY TERMINATE THE SIGHT-LINE FROM WASHINGTON STREET.

The detailed plan of the mall from the 25-year master plan compares the proposed plan in 1930 to that of OSU's centennial mall in 1989. (Courtesy of Library of Congress, HALS Collection.)

SECTION A-A OF 1930 CAMPUS PLAN

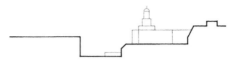

SECTION A-A OF CURRENT CAMPUS - 1990

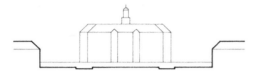

SECTION B-B OF 1930 CAMPUS PLAN

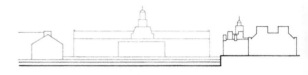

SECTION B-B OF CURRENT CAMPUS -1990

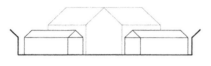

SECTION C-C OF 1930 CAMPUS PLAN

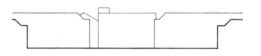

SECTION C-C OF CURRENT CAMPUS -1990

The section diagrams of the mall from the 25-year master plan compare the proposed plan in 1930 with the as-built site on the centennial of OSU in 1989. (Courtesy of Library of Congress, HALS Collection.)

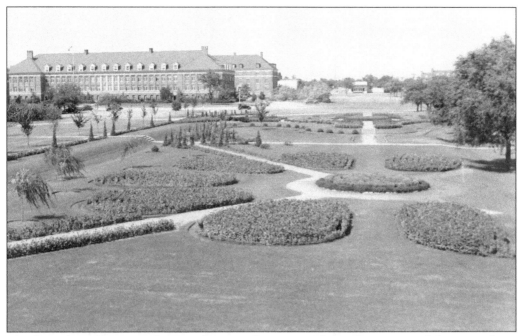

The formal gardens are a legacy of Bryan Thompson. Throughout most of the year, those who stroll through them will see an array of color; the flower beds contain principally canna, lantana, mums, and petunias, with fragrant magnolias trees in the summer.

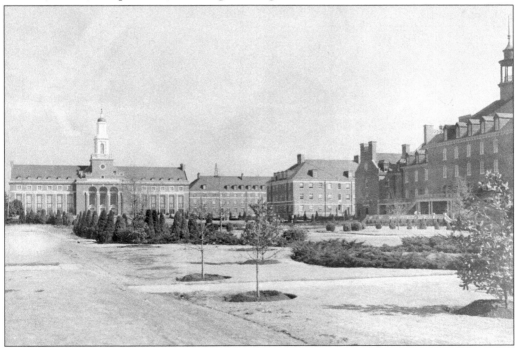

This is a view of the campus after the completion of the library, Classroom Building, and the student union.

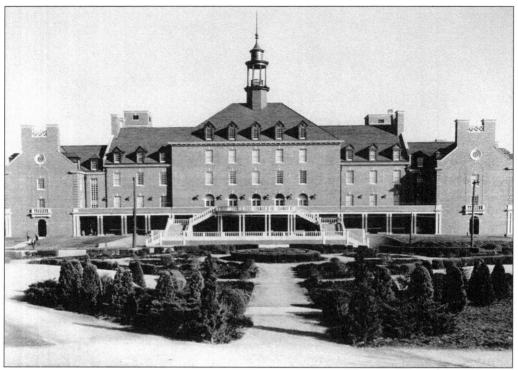

This c. 1955 photograph shows the formal gardens in front of Oklahoma State Student Union.

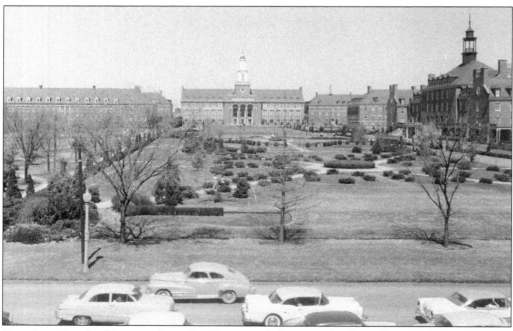

Here is a view looking north to the library and showing the formal gardens on the south lawn (mall) from University Avenue.

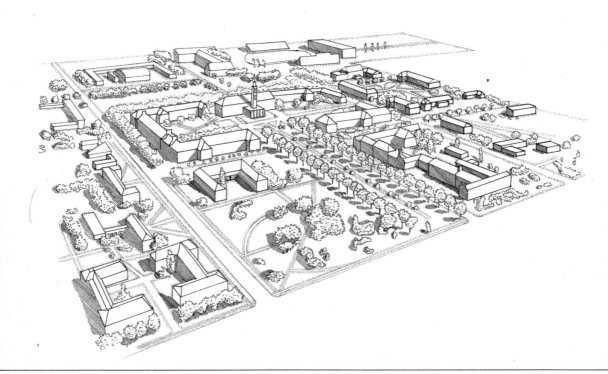

An aerial perspective drawing from a painting of the as-built campus of 1945 depicts how much of the 1930 master plan had been implemented. (Courtesy of Library of Congress, HALS Collection.)

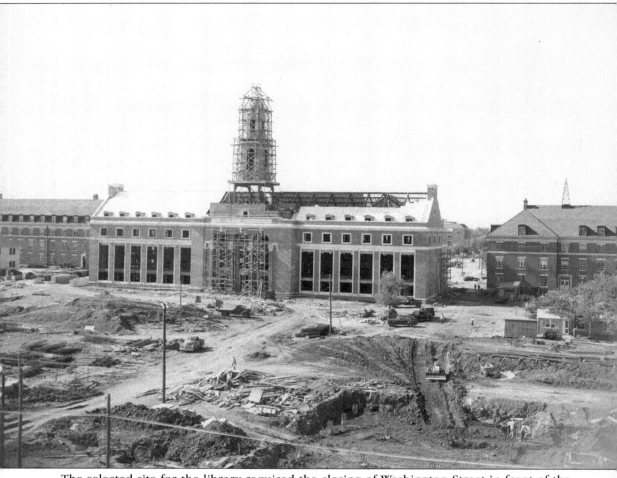

The selected site for the library required the closing of Washington Street in front of the building where the power poles are located. Construction of the library, considered the centerpiece of the 25-year plan, began in May 1950. At the time of the its 1953 opening, this was the fifth-largest library in the nation.

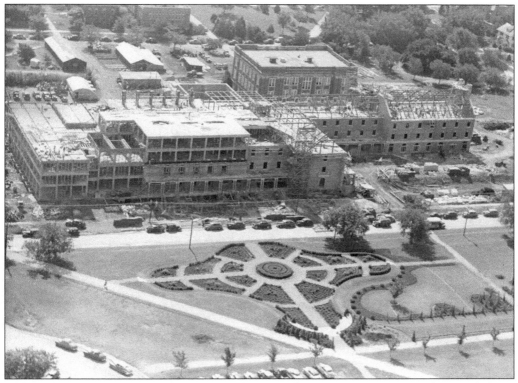

Oklahoma State Student Union is located north of University Avenue on the south lawn (mall) and faces east.

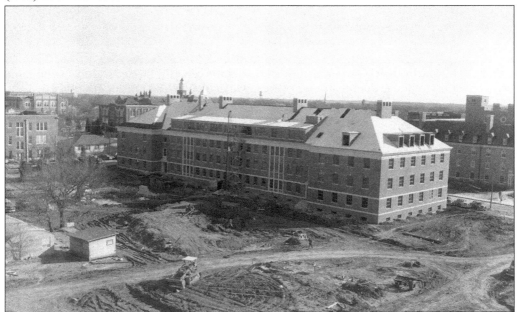

The Classroom Building, north of the student union, is centrally located on the campus for the convenience of the students.

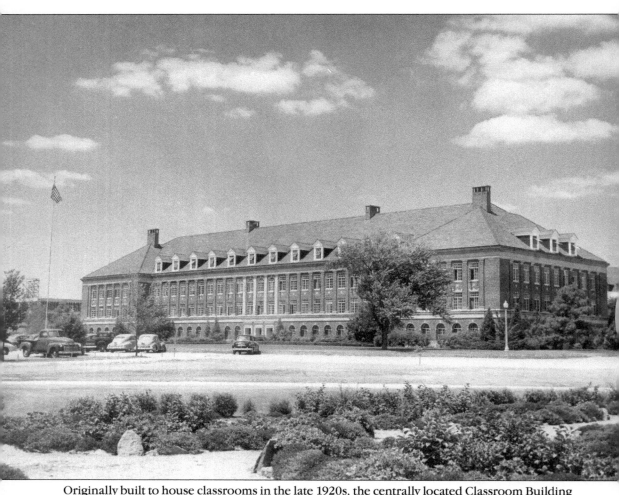

Originally built to house classrooms in the late 1920s, the centrally located Classroom Building was converted to house administrative offices, which include the president's office.

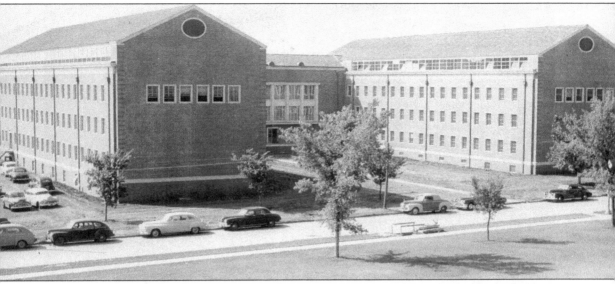

The home economics building west was under construction when the College of Home Economics celebrated its 50th anniversary. The building was originally planned with three wings but was constructed with two wings and contained 190 classrooms and approximately 57,256 square feet of space. Georgian-style dormer windows were not used on this building for practical and economic reasons so as to provide rows of windows with an uninterrupted roofline as well as more light and floor space. The building contained many architectural features that highlighted the home economics profession. The interior featured floor-to-ceiling display cases as well as the functional second- and third-floor bay windows, which were used extensively by those students in clothing, textiles, and merchandising.

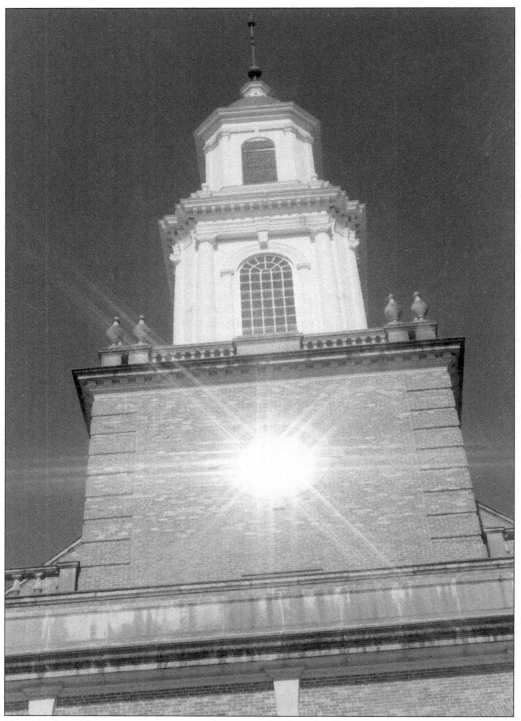

The 182-foot library tower serves as the major landmark of the campus. The tower also houses a carillon that plays periodically during the day.

Roofs on the campus were damaged in an unusually violent hailstorm in the spring of 1950. It lasted approximately 20 minutes and resulted in over $1 million in damage.

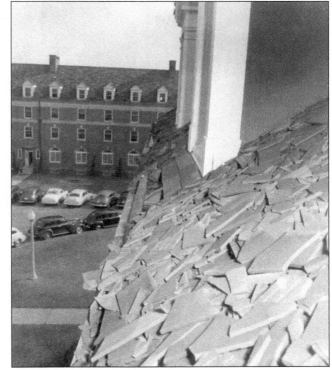

The south entrance to Edmon Low Library provides a view of the handsome wide stairway that leads to the second floor. The steps are built of Kasota stone from Minnesota. Twin columns of Italian marble flank the stairway.

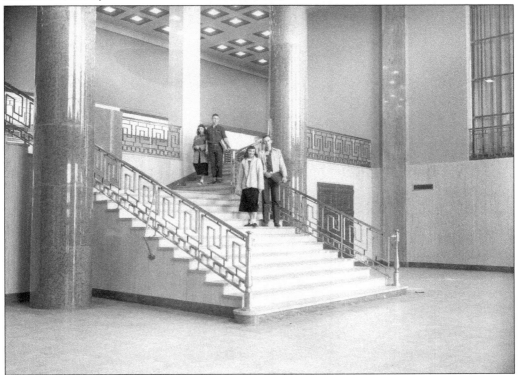

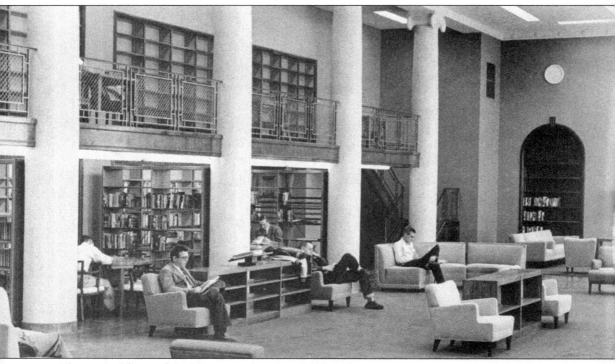

The second floor of the library on the east end provides an attractive browsing room. Patrons can easily find reading material, which can be enjoyed while sitting on comfortable chairs or sofas.

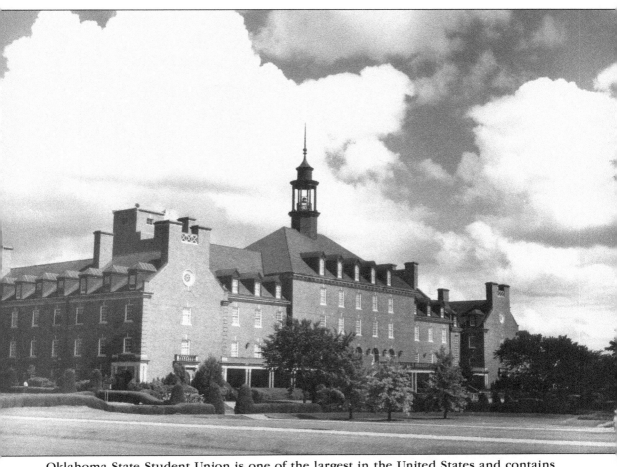

Oklahoma State Student Union is one of the largest in the United States and contains commercial shops as well as an adjoining hotel.

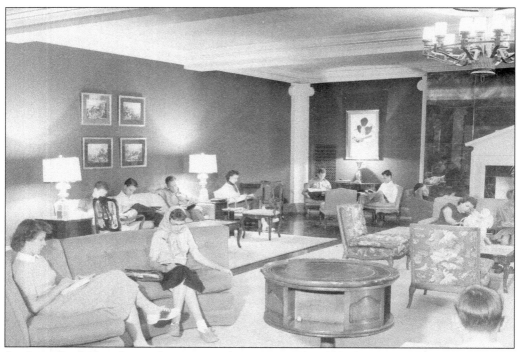

Students flocked to the student union when it opened in fall of 1950. The French Lounge in the student union was a favorite place to relax.

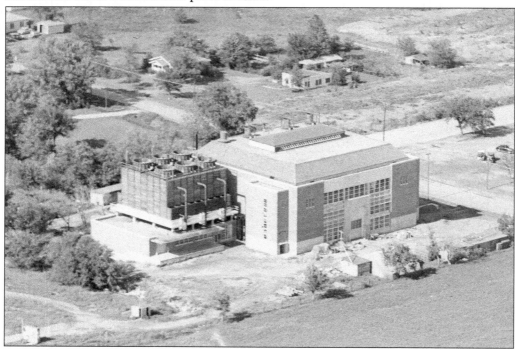

The power plant was built on the end of the north lawn (mall) on what is now Hall of Fame Avenue near the intersection with Washington Street.

A lovely walkway connects the student union to Edmon Low Library. The sidewalks on the campus were organized to place the focus on the library.

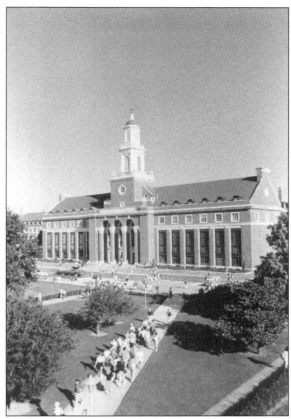

The drawing of the as-built campus for the centennial in 1989 shows how much of campus site plan from the 25-year 1930 master plan had been implemented. (Courtesy of Library of Congress, HALS Collection.)

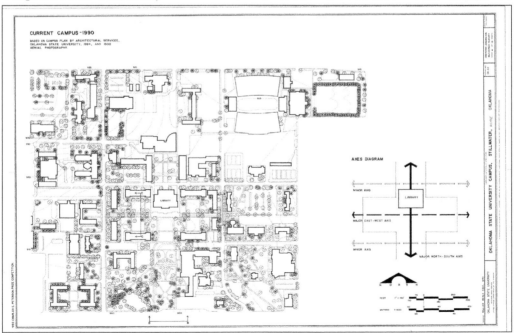

CURRENT CAMPUS PERSPECTIVE, 1990

BASED ON AERIAL PHOTOGRAPH TAKEN BY SCOTT LAWRENCE
KILGO IN MARCH, 1990.

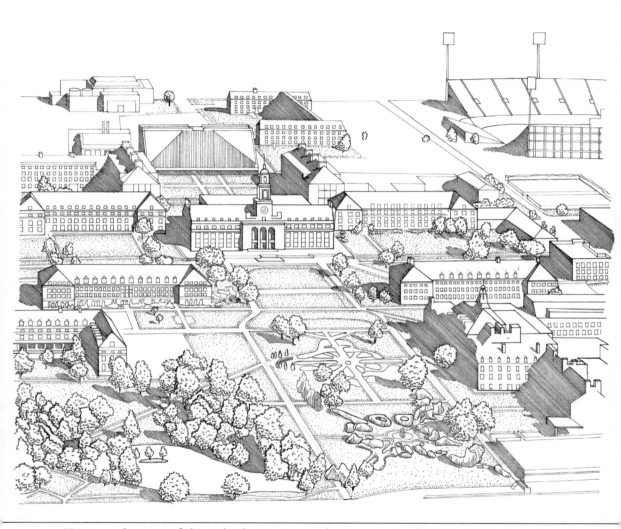

Here is a drawing of the as-built campus on the centennial of OSU in 1989. (Courtesy of Library of Congress, HALS Collection.)

Five

FAUX GEORGIAN PERIOD
1960–1979

At the beginning of the 1960s, due to President Bennett's farsightedness, the 25-year campus plan (1930–1955) was nearly completely built out due to the influx of students following the end of World War II. Upon the untimely death of President Bennett and his wife in an airplane accident in Iran in 1957 while on a Point 4 Mission for the federal government, the plan was nearly completed. Without President Bennett's leadership, the support for the Neo-Georgian architectural style waned, the campus site plan was not extended, and OSU continued to grow without an overall extended plan. In 1964, Wilber retired as campus architect, and the campus architect's office was transferred to the Physical Plant Office. During this period, academic buildings—such as Agricultural Hall, the College of Human Sciences Building, and the Spears School of Business Building—were required to be built in a faux Georgian style with scale and details representing Georgian elements and with similar material and color, whereas other buildings—such as the chapel, Kerr-Drummond Residence Halls, and the off-campus President's House—were designed at a different scale and in a contemporary style.

In 1969, in an effort to provide new planning guidelines, Caudill Rowlett Scott's campus concept plan was developed. The concept plan focused primarily on pedestrian circulation with the idea of placing future academic buildings within a 10-minute walking distance, the time required for students to change classes from one building to another. To recognize OSU's international activities, the International Plaza was established on the north side of the library with a display of the flags of the countries served by OSU as well as several monuments such as the bronze dove column. Other buildings completed during this time besides those already mentioned include the Student Health Center and the Agriculture Extension Offices.

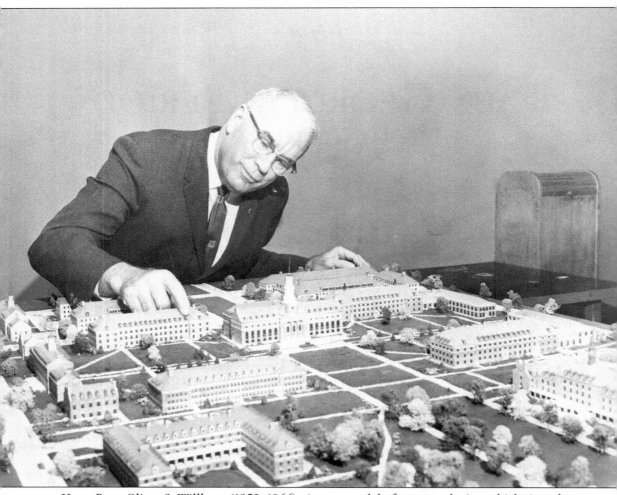

Here, Pres. Oliver S. Willham (1952–1966) views a model of campus during which time the institution changed from a college to a university. Willham inherited from Henry G. Bennett a massive building program already in progress, which called for renovations and major new construction. (Courtesy of Oklahoma State University Archives.)

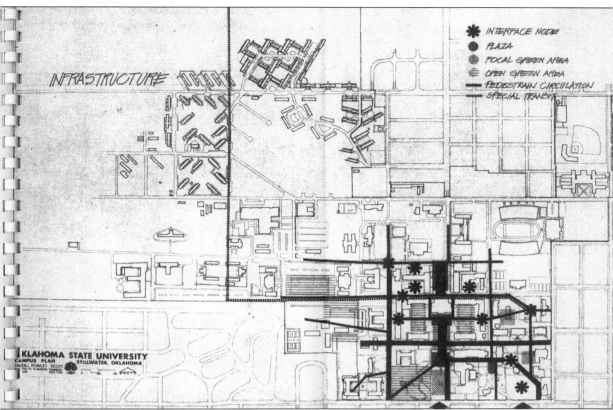

The concept plan was developed for the core of the campus in the area east of Knoblock to slightly west of Monroe Street, slightly north to Hall of Fame Avenue and south to University Avenue. The plan recommends Monroe and Hester Streets be converted to limited-access streets. In addition, the plan recommends sites for additional student housing and that some of the old obsolete, nonconforming Neo-Georgian architectural style be removed. The plan shows a limited scope for expansion of the campus.

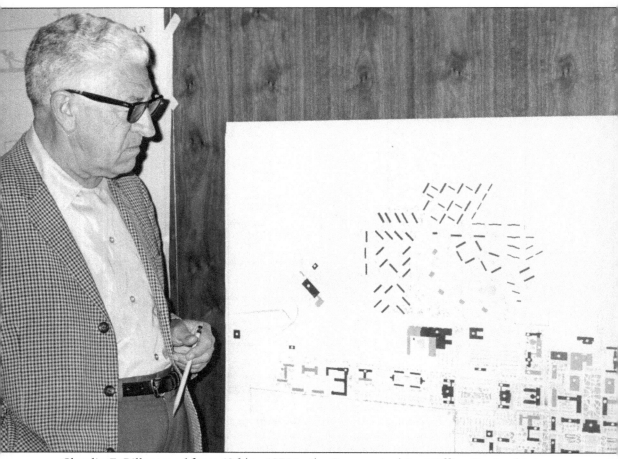

Chaplin E. Bills served from 1964 to 1971 in the Campus Architect Office. During his tenure as campus architect, 32 buildings were completed.

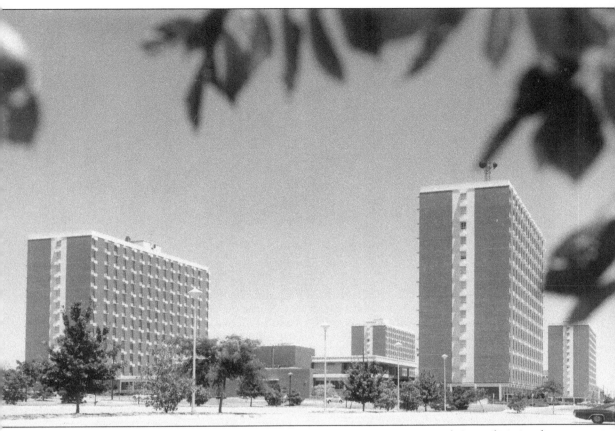

The Willham Complex, in the foreground, and the Kerr-Drummond Complex, in the background, represent a departure from medium-rise buildings in favor of high-rise buildings, which do not have the traditional dormer windows of the earlier Georgian-style residence halls. However, the facilities do retain similar brick color and beige stone trim. In each of the complexes, one residence hall is for men and the other is for women. The halls are connected by a two-story building that provides a lobby and cafeteria on the lower level and a lounge and recreation area on the second floor. The twin 12-story Kerr-Drummond Halls opened in 1967, and after 46 years, they were declared "out of date" and torn down during the summer of 2015.

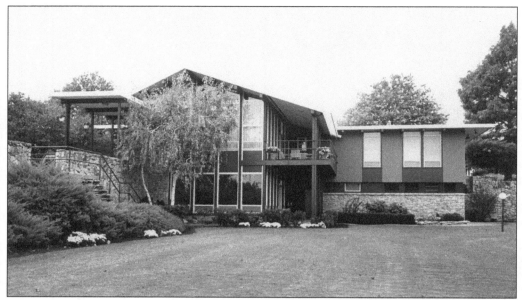

After the 1917 President's House was razed in 1952 for the Bennett Memorial Chapel, the president did not have an official university-owned residence until the early 1960s. The new off-campus house in contemporary design was at 1600 North Washington Street.

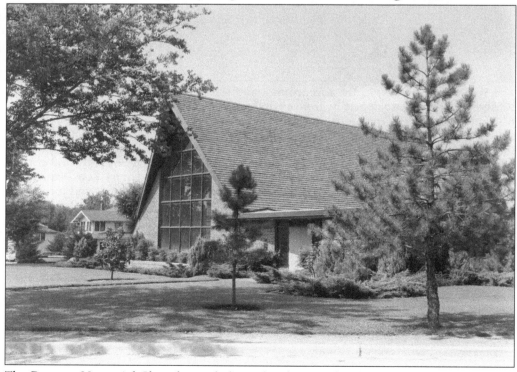

The Bennett Memorial Chapel was dedicated in honor of Oklahoma A&M College's war dead and Dr. and Mrs. Henry G. Bennett, who were killed in an airplane crash in Iran on a Point 4 Mission.

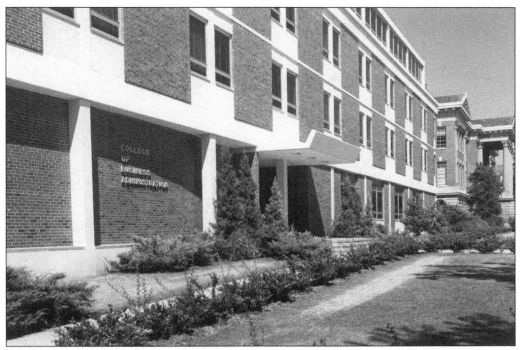

Here, the College of Business Administration has moved into its permanent 75,000-square-foot home with five case study classrooms in an attached annex.

The Oklahoma State University Student Health Center opened in 1976. The one-story building with a full basement consisted of examining rooms, a pharmacy, and offices for eight physicians plus the director, as well as private and semiprivate rooms for 18 students. The center is located on Farm Road diagonally across the street from Agricultural Hall.

The College of Veterinary Medicine is located on the west side of the campus off Farm Road.

In 1957, the last class to graduate from Oklahoma A&M College provide this monument as a gift to the campus. The granite monolith was erected in 1984. The class of 1956 two years earlier donated the funds for the sidewalk in front of the monument along University Avenue.

The dove on International Mall, which was presented to OSU by the International Students Association, symbolizes OSU's involvement in international education. The Noble Research Center for Agriculture and Renewable Natural Resources is at the north end of the mall.

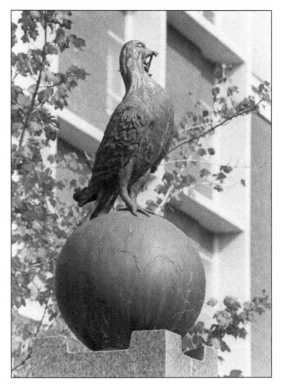

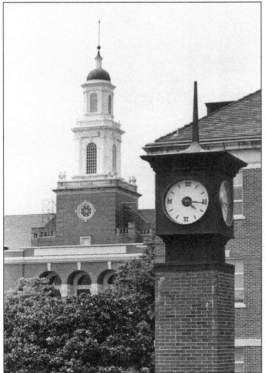

The local chapter of Chi Omega sorority gifted the Chi O Clock to the university to celebrate its golden anniversary on campus in 1970. The clock tower is located between the Classroom Building and the student union, with the library seen in the distance. The tower is the best-known landmark on the campus. Thousands of students pass by it every day.

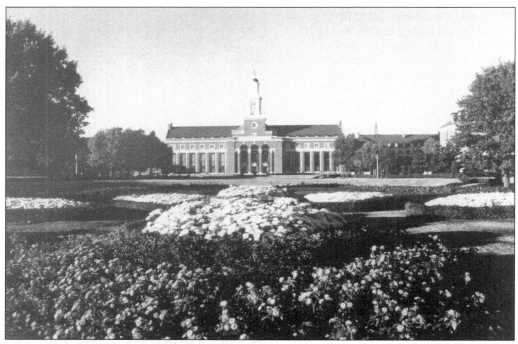

Here, one sees the library from the formal gardens in the south lawn (mall).

The walk, now known as the Legacy Walk, is on the east-west mall as part of the cruciform cross axis for the campus that passes on the south side of Edmon Low Library and is enhanced by attractive lawns, trees, and benches.

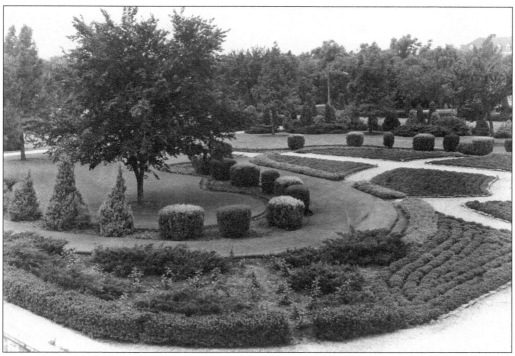

Here is a view of the formal gardens from the steps of Oklahoma State Student Union on the west side.

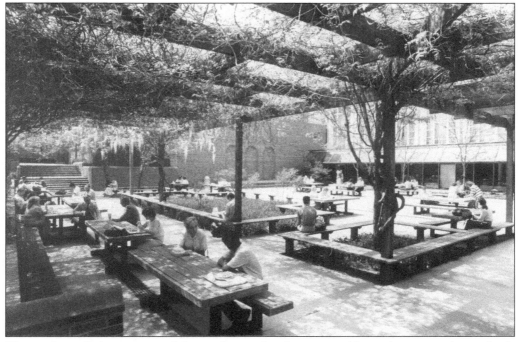

The outdoor dining terrace of the student union is protected by a vine-covered sun shade located on the ground floor.

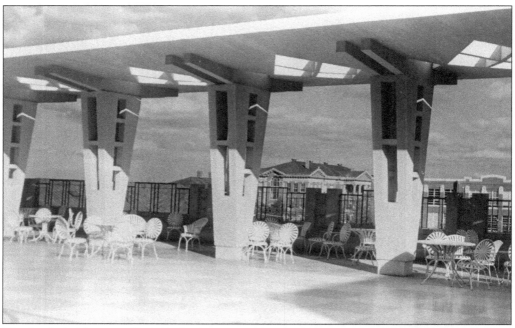

The Starlight Terrace offered refreshments and provided a view of the campus from the top floor of the student union.

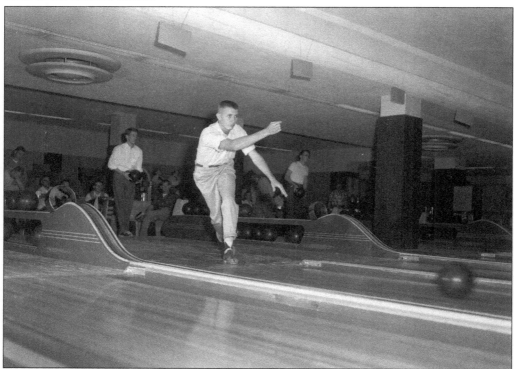

The bowling alley was located in the basement of Oklahoma State Student Union; this form of recreation was available to students on campus.

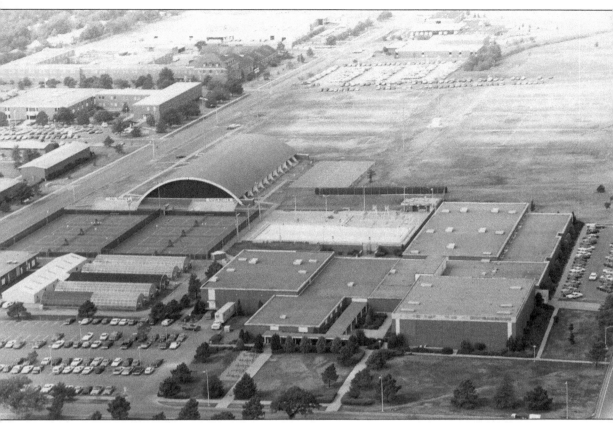

The Colvin Physical Education Center created a new era in physical education, intramural, and recreational programs for the university. Fifty percent of the cost of the complex was financed in part by a student fee established by the student government. The curved-roof Colvin Center Annex, shown in the upper left corner, provided additional racquetball and handball courts, an indoor track, and several combination basketball/tennis courts.

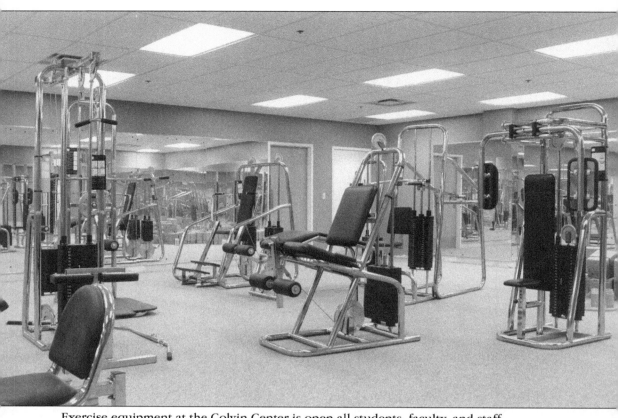

Exercise equipment at the Colvin Center is open all students, faculty, and staff.

Six

Modern Period
1980–1999

To prepare for placing the Noble Research Center for the 21st century, the offices of Sparks, Martin, Easterling with William and Kessler & Associates were retained in 1980–1982 to prepare development concepts for the campus. These concepts linked all portions of the campus into one plan and recommended a site in for the Noble Center on the lawn (mall), north of the library and south of the power plant. The competition for the Noble Center required the design to reflect the 21st century. This decision represented a complete departure from the Neo-Georgian style. Architects Collaborative of Boston, in association with Frankfort, Short & Burza, was selected for the project.

To improve and enhance the landscape of the campus, Howell & Vancuren, Landscape Architecture firm from Tulsa, was retained in 1999 to prepare a landscape master plan for the campus. The plan focuses primarily on improving the arrangement of plant material on the campus. Hedges that existed along the walks were removed to open up the grounds.

Anticipating a major campus building program to provide a sound foundation for the future of the campus, OSU Faculty Council's Campus Facilities, Safety, and Security Committee undertook a case study approach, examining the campus planning function at selected college campuses throughout the country that were considered well planned. The committee members included the author of this book, Charles Leider, landscape architect and urban planner; Suzanne Bilbeisi, architect; and Khaled Gasem, chemical engineer; along with two non-design faculty members and one undergraduate and one graduate student. Each committee member was requested to select one or two campuses to investigate. Some of the campuses studied included Michigan State University, Yale University, University of California at Berkeley, University of Wisconsin, Kansas State University, John Hopkins University, and Cornell University. Each member reported on his or her findings to the committee. The study found all of the successful planning functions were not located in the campus physical plant offices but were independent offices that reported directly to either the president or vice president in charge of physical planning. The offices were focused on site planning instead of architectural design or engineering requirements and were headed by persons trained in landscape architecture. The committee recommended to the faculty council an independent planning office be established and staffed with appropriate design disciplines, including those which deal with the built environment: architecture, landscape architecture, interior design, civil engineering, and construction management. The recommendation was approved by the faculty council and submitted to the administration, which approved and established a Long Range Planning Office, headed by a civil engineer with an architect as an assistant; the landscape architecture function was left in the Physical Plant Office under the grounds director.

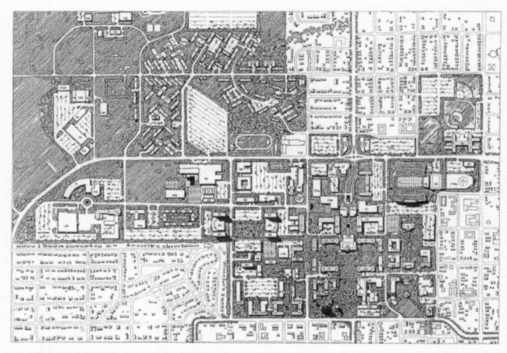

1982 Development Concepts

Sparks, Martin, Easterling, William and Kessler & Associates

Courtesy of Oklahoma State University Archive

Sparks, Martin, Easterling with William and Kessler & Associates of Tulsa were retained in 1980–1982 to prepare master plan development concepts. These concepts linked all portions of the campus into one plan and recommended a site for the Noble Center on the mall north of the library and south of the power plant. (Courtesy of Long Range Planning Office, Oklahoma State University, Stillwater.)

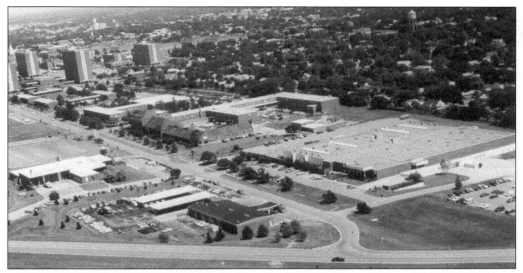

The College of Veterinary Medicine complex is located on the west edge of the campus along Farm Road at the intersection of Farm Road and Western Street. The largest structure on the right is Boren Veterinary Medical Teaching Hospital, adjacent to the original veterinary medicine building. At the center left is the Oklahoma Animal Disease Diagnostic Laboratory. (Courtesy of Oklahoma State University Archives.)

The city and the university collaborated in developing and sharing the airport, which serves as an important transportation link for both. The facility is used for OSU's flight-training program.

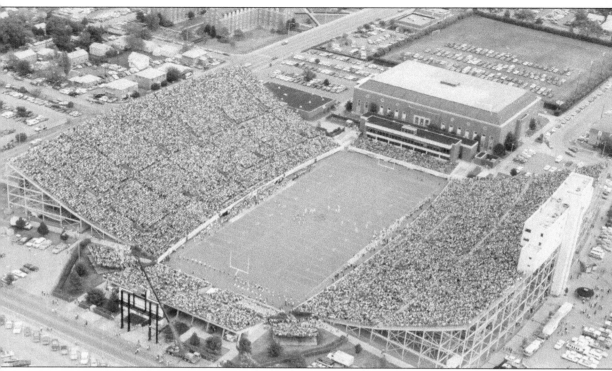

Lewis Stadium began taking shape as a U-shaped structure, starting in the 1920s with the idea of accommodating a basketball arena at the open east end. The first major portion of the stadium was the steel and concrete portion of the current stadium built on the south side in 1924. Starting in 1929, eight thousand permanent seats were built on the north side for an overall capacity of 13,000. In 1947, with the large increase in student enrollment after World War II, the south side was increased from 20 to 53 rows—along with a press box—to accommodate nearly 30,000. Before the start of the 1950 season, 10,600 seats were added to the north side, increasing capacity to 39,000, which also included temporary end-zone bleachers. With the removal of the cinder track after 1971, twenty rows of permanent seats were added to both sides along with an artificial turf. For the Bedlam Series game with the University of Oklahoma in 1979, the stadium reached an all-time attendance record of 51,457.

Dr. Donald L. Cooper served as the director of the Student Health Center and physician for university varsity athletic programs. Dr. Cooper was very dedicated, and he personally treated the injuries of the athletes. He was also internationally known for his work in sports medicine. As director, he was successful in winning support for an increase in student health fees to support a new health center.

In the late 1980s, Gallagher Hall was completely remodeled and renamed Gallagher-Iba Arena. The angle of the side sections was decreased and the ceiling of the playing area was replaced with a lighter color, creating the appearance of an even higher ceiling. Brass fixtures were used to accent the basketball arena.

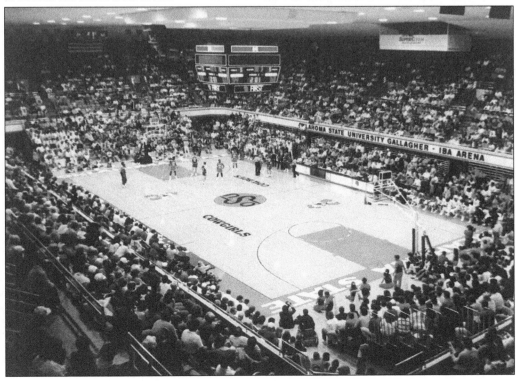

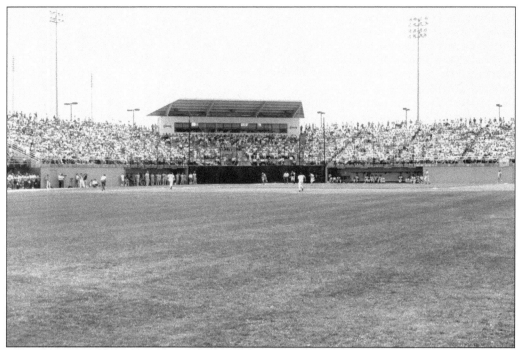

The baseball stadium was officially dedicated in 1982 and is partially covered. The facility can seat 3,100 spectators and is fully lighted to permit night games.

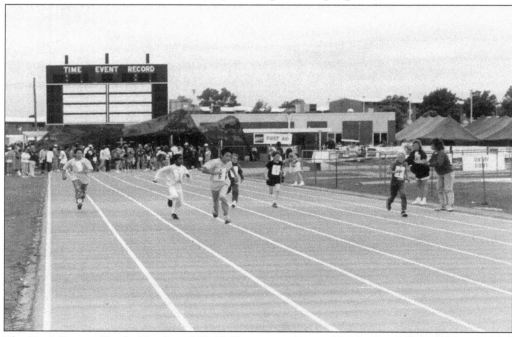

The Kaye Barrett Droke Track and Field Center was located in the northwest portion of the campus. The facility contained an oval track with eight running lanes along with dressing and training rooms and a coach's office.

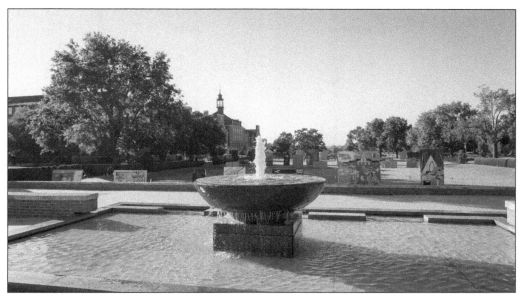

To celebrate homecoming, the fountain in front of the library is dyed orange each year to show school spirit.

The main entrance to the library faces University Avenue and is located at the north end of the mall on the east-west axis walkway.

A new wing was added to the west side of the College of Human Sciences Building. The west wing is connected to the main building by an enclosed glass walkway on the second floor.

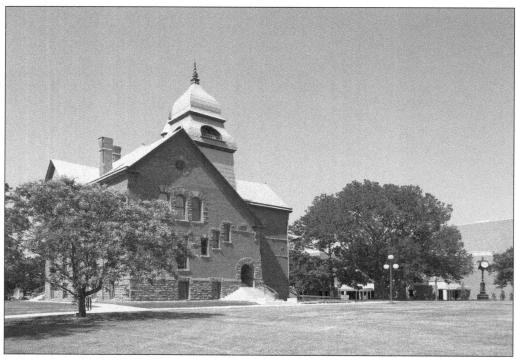

Old Central has been preserved. Today, it is designated as the home for the OSU Honors College and is used for classes and faculty offices.

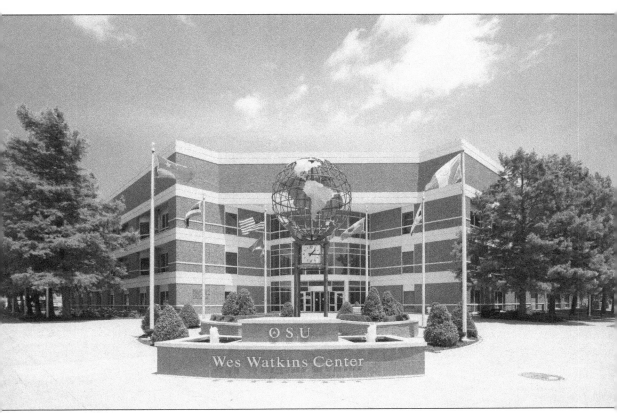

The Wes Watkins Center was established under the leadership of Wes Watkins, Third District Oklahoma congressman. The center helps to internationalize OSU's campus and the state of Oklahoma by fostering international education, outreach programs, and activities throughout a 35,000-square-foot building. The center contains the Study Abroad Program, English Language Institute, and the Graduate Program in International Studies and is located on the northeast corner of the intersection of Hall of Fame Avenue and Washington Street, a short distance north of the library.

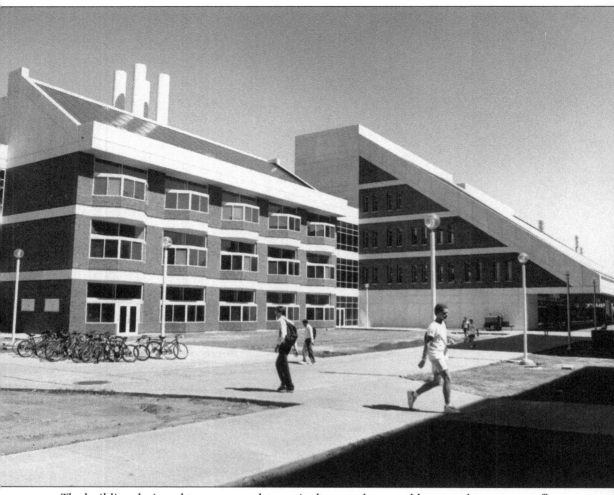

The building designed to accommodate agriculture and renewable natural resources reflects the approaching 21st century in its futuristic style by departing from the Neo-Georgian style of the campus. The building is located prominently on the north-south axis of the campus, south of Hall of Fame Avenue and to the north of the library. It houses the School of Geology and the Departments of Plant Science and Entomology.

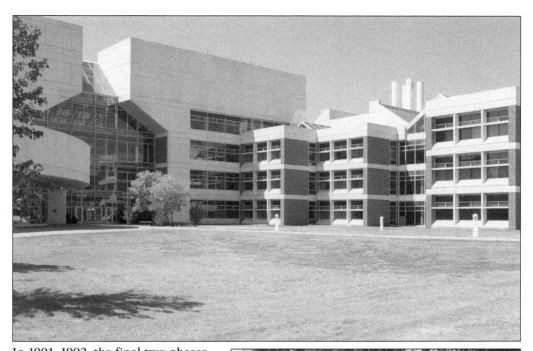

In 1991–1992, the final two phases of the Noble Research Center, consisting of two 63,000-square-foot, three-story structural-concrete buildings, were completed using self-bands of cast stone with brick veneer and bay windows enclosing the two laboratory facilities. Interior amenities include laboratory casework, vent hoods, and walk-in coolers on every floor. Upon completion, all of the Noble Research Center buildings were connected with a three-story open atrium, enhancing the feeling of one continuous facility.

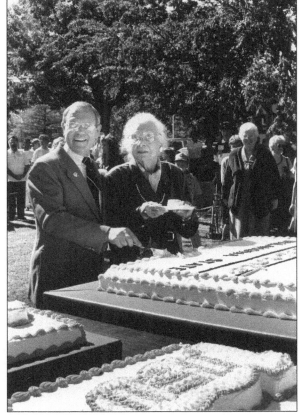

Here, President Campbell leads the campus-wide celebration by cutting the cake and serving Elizabeth Oursler Taylor, the oldest living graduate, on the Willard Hall lawn.

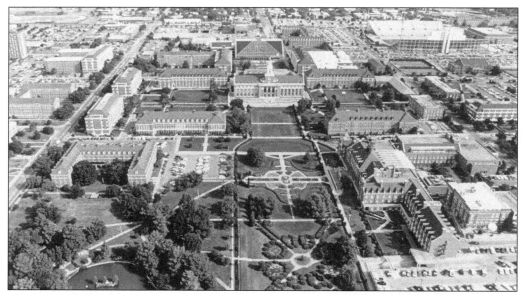

This view of Oklahoma State University on its centennial shows the vast influence that the campus master plan has on the university.

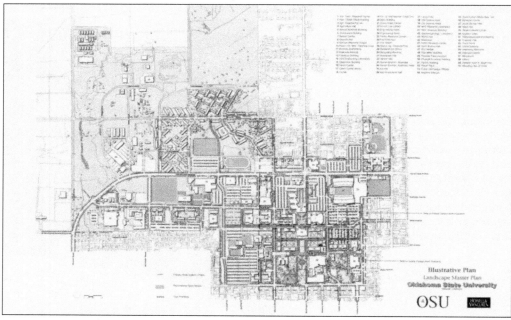

The plan prepared by Howell and Vancuren addresses campus beautification, building construction, and landscape projects. It contains a record of existing facilities' conditions and landscape features, and it proposes guidelines for future development. The plan focuses on upgrading the plant materials used throughout the campus and recommends doing away with the trifoliate throne hedges, which outlined the walks in the quadrangles, to create a more open feeling as well as adding more trees along the walks and roadways to enhance the appearance of the campus. (Courtesy of Long Range Planning Office, Oklahoma State University, Stillwater.)

Seven

MILLENNIAL PERIOD
2000–PRESENT

Following the establishment of the Long Range Planning Office, the Benham Company, located in Oklahoma City, was retained to prepare a 25-year general master plan for the campus. Pres. David Schmidly and the Stillwater community were not completely satisfied with the Benham plan and retained two architecture faculty members, Professors Jones and Bilbeisi, to revise the plan, which was presented and approved on March 3, 2006, by the Oklahoma State University System/A&M College Board of Regents. The plan approved by the regents calls for $826 million in funding toward an initial five-year program for several new academic and student life facilities; all athletic projects, including development of the athletic village; four additional parking facilities; a campus irrigation system; the reopening of Hall of Fame Avenue; and the rerouting of Hester Street prior to construction of the west end zone of Boone Pickens Stadium. The plan also calls for building the Multi-Modal Transfer Terminal to provide bus service for the campus, Stillwater, and service to the Tulsa campus; a science building; an addition to the College of Human Sciences Building; an addition to the veterinary college building; a library storage building; and an information technology center.

In 2006, OSU alumnus Boone Pickens supported the creation of the athletic facilities in the northeast portion of the campus by creating a site plan for an athletic village. Pickens funded the acquisition of the property north of the stadium from Hall of Fame Avenue to Rosewood Street and from Washington Street to Duck Street for the OSU Athletic Village. Carried out under the direction of John Houck, the plan for the athletic village calls for enlarging the stadium by enclosing the west end into a U-shaped form and double-decking the stadium. With the support of other donors, the plan also includes the funding and creation of other facilities, such as a practice field building, enlargement of the training center at Gallagher-Iba Arena, a new tennis center, a new men's baseball field and stadium, new track facilities, and the renovation Allie Reynolds for women sports.

In responding to student demand for on-campus residential housing with suites and apartment, the twin 14-story Willham Hall North and South Towers were demolished in 2005 to create residential buildings that included private bedrooms for each student in a suite situated around a central common area. In addition, similar residential buildings have been built on the northwest side of the campus along Hall of Fame and McElroy Avenues.

To fully develop the campus master plan and enhance the building sites and vehicular circulation of the 25-year general OSU/Benham master plan with landscape amenities, Alaback Design Associates, a landscape architecture firm from Tulsa, was retained in 2011 to prepare a landscape master plan. The plan resulted in applying sustainable design principles; installing new entrance monuments and pedestrianizing of Monroe Street by eliminating the street curbs and replacing asphalt paving with colored pervious pavers; improving pedestrian circulation through the widening of the walkways; and evaluating and revising the placement of vegetation, benches, and streetlights.

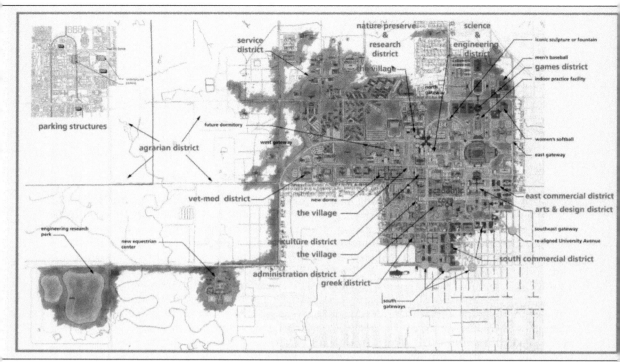

The labels in the map read:

nature preserve & research district
service district
science & engineering district
iconic sculpture or fountain
men's baseball
games district
indoor practice facility
the village
north gateway
parking structures
future dormitory
west gateway
women's softball
east gateway
agrarian district
vet-med district
new dorms
the village
east commercial district
arts & design district
southeast gateway
re-aligned University Avenue
engineering research park
new equestrian center
agriculture district
the village
administration district
greek district
south commercial district
south gateways

The Benham plan proposes to link the surrounding research park, agronomy farms, and arboretum with a new north entrance off Washington Street. An enlarged athletic area and new major water features are also included. Initially, the plan also wanted to incorporate surrounding non-university property, such as shopping areas and Greek and other private housing, into the campus. (Courtesy of Long Range Planning Office, Oklahoma State University, Stillwater.)

104

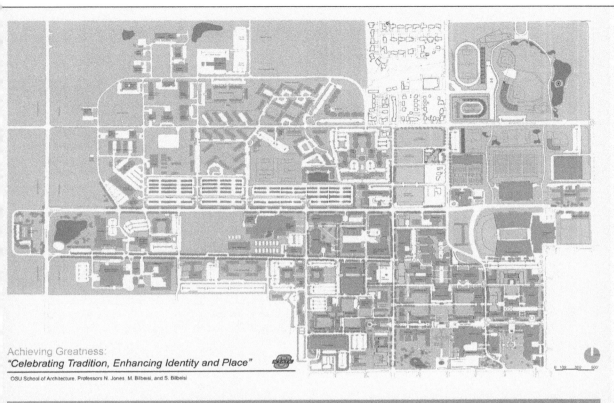

Master Plan 2025
Oklahoma State University
Stillwater Campus

The Benham plan was scaled back by OSU to the campus proper to show the building needs for athletics and all the colleges. (Courtesy of Long Range Planning Office, Oklahoma State University, Stillwater.)

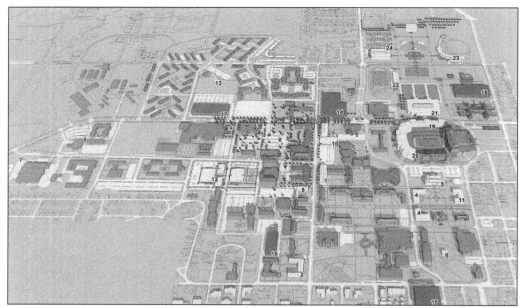

This outline of what the campus of OSU could be is depicted in a view looking north from University Avenue. (Courtesy of Long Range Planning Office, Oklahoma State University, Stillwater.)

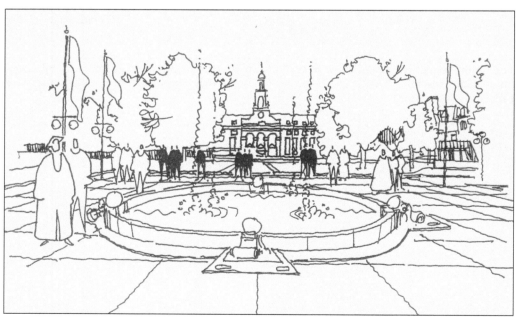

This sketch with a view looking toward the library envisions a circular, raised water feature on the south mall. (Courtesy of Long Range Planning Office, Oklahoma State University, Stillwater.)

106

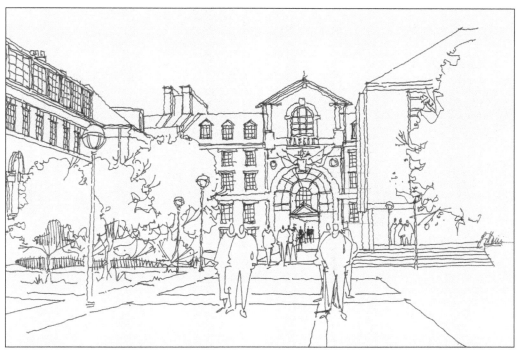

This sketch helps to show the scale and architectural style of future buildings on the campus. (Courtesy of Long Range Planning Office, Oklahoma State University, Stillwater.)

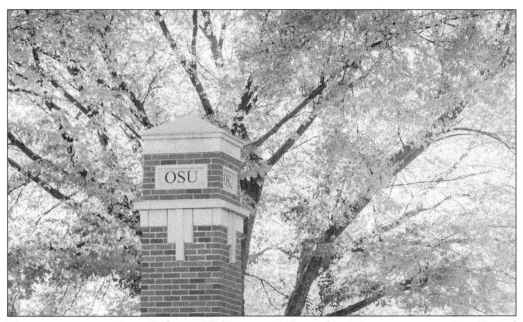

The campus master plan calls for establishing monuments at key campus entrance points. Typical of those installed, the column pictured is located on one side of Monroe Street at the intersection of University and Hall of Fame Avenues; it is mirrored on the opposite side of the street with a second column. (Courtesy of Oklahoma State University, University Marketing.)

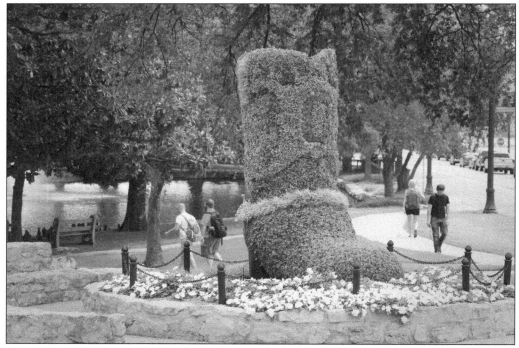

The major pedestrian and vehicular entrance is located at the OSU Boot near the intersection of University Avenue and Monroe Street adjacent to Theta Pond. (Courtesy of Oklahoma State University, University Marketing.)

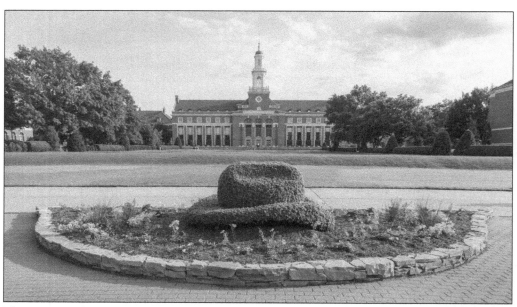

The OSU Cowboy Hat is used as a design feature at the foot of the south mall on University Avenue. (Courtesy of Oklahoma State University, University Marketing.)

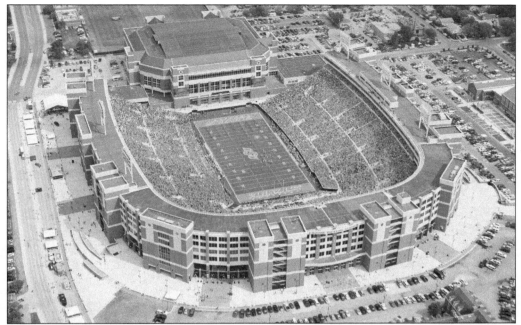

Lewis Field was officially renamed Boone Pickens Stadium in 2003 in honor OSU alumnus T. Boone Pickens. Pickens donated $165 million to the university's athletic program, the largest single donation for athletics to an institution of higher education in American history, to create an athletic village and upgrade the football stadium. The improvements to the Boone Pickens Stadium increased its capacity to 53,000 spectators. The stadium's exterior was also updated to match the modified faux Georgian architecture of the campus, and a connection to the Gallagher-Iba Arena was put in place. The stadium turf was replaced in 2005. (Courtesy of Oklahoma State University, University Marketing.)

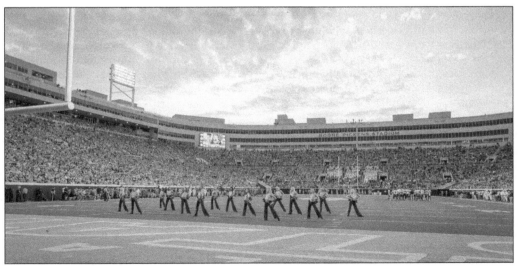

The cheerleading squad is pictured on Lewis Field during a home football game. (Courtesy of Oklahoma State University, University Marketing.)

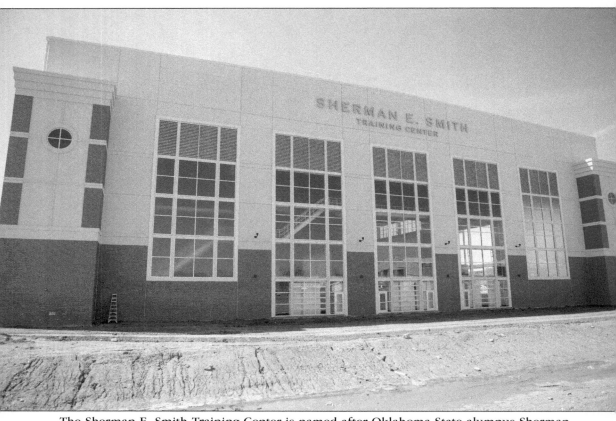

The Sherman E. Smith Training Center is named after Oklahoma State alumnus Sherman E. Smith, who donated $20 million to the Oklahoma State University athletics department to endow the maintenance and general upkeep of the facility. Built at a cost $19 million, the 92,000-square-foot structure is one of the largest facilities of its kind in the Big 12 Conference. The training center is capable of allowing indoor practices for several sports, including football, soccer, baseball, softball, and track and field. Three additional football practice fields—one AstroTurf with a north-south orientation and two natural-grass surfaces, one north-south the other east-west—are directly east of the training center. The training center is located north of Hall of Fame Avenue, directly across from Boone Pickens Stadium. (Courtesy of Oklahoma State University, University Marketing.)

Located on the north side of Boone Pickens Stadium on Hall of Fame Avenue is a practice facility for all field sports, particularly football. (Courtesy of Oklahoma State University, University Marketing.)

The Greenwood Tennis Center, the second major project in the Oklahoma State University Athletic Village, was unveiled in January 2014, with the indoor portion of the complex hosting its first varsity matches. The 12 outdoor courts were opened later that year. Built in 2014, the Michael and Anne Greenwood Tennis Center has already provided Oklahoma State University's men's and women's tennis programs with an unbelievable home-field advantage. The 50,000-square-foot tennis center is located just north of Boone Pickens Stadium. The indoor facility houses six tennis courts, along with coaches' offices, locker rooms, and a sports medicine hub complete with a hydrotherapy center. The indoor facilities are able to seat at least 350 spectators. The center includes 12 lighted outdoor tennis courts in two sets of six courts. The courts are set up to allow fan viewing of each match being played in both the indoor and outdoor venues. (Courtesy of Oklahoma State University, University Marketing.)

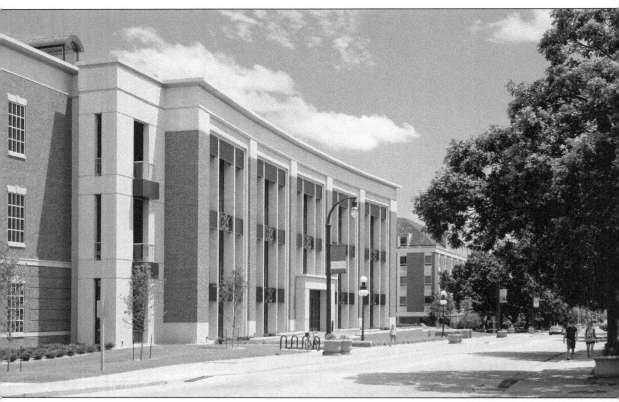

The Henry Bellmon Research Center (HBRC) is a first-of-its-kind facility on the campus and is named after the late Bellmon, a former US senator and Oklahoma governor. Bellmon graduated from OSU (then Oklahoma A&M) in 1942. The HBRC was completed in 2010 as the first of a three-phase complex designed to enhance research capabilities at OSU. The completion of two additional phases, which include the renovation of the physical sciences building, will make the HBRC and surrounding areas a hub of interdisciplinary activity. The building facilitates interdisciplinary research for 200 faculty members, postdoctoral students, and graduate students to form six main focus areas: synthetic chemistry, biodiversity, biophysics, photonics, bioforensics, and biogeophysics. (Courtesy of Oklahoma State University, University Marketing.)

The 50,000-square-foot, three-story sustainable North Classroom Building is used by OSU and Northern Oklahoma College. The building offers the latest in teaching tools and a beautiful learning environment, which includes energy-efficient lighting, windows, and heating and air-conditioning. The building is wireless and features the latest multimedia equipment in all classrooms. It is much closer to the majority of the campus's residence halls, which are located on the north side of campus, and is across the street from Northern Oklahoma College. (Courtesy of Oklahoma State University, University Marketing.)

The mission of Helmerich Research Center (HRC) is focused on providing research, testing, technology transfer, and education to advance the region's aerospace, energy, manufacturing, transportation, electronics, and medical industries. Research at the HRC has a positive impact on the economy and quality of life for the region and provides opportunities for OSU students and faculty to work hand in hand with industries. (Courtesy of Oklahoma State University, University Marketing.)

The Multi-Modal Transfer Terminal and parking garage are located on the southeast corner of Hall of Fame Avenue and Monroe Street at the north side of the campus. The center contains a bus terminal for university and community passengers and is a spot for transfer from one route to another, including bus service to the Tulsa campus and to an intrastate bus line. (Courtesy of Oklahoma State University, University Marketing.)

Tickets for the bus service are available for purchase in the lobby. (Courtesy of Oklahoma State University, University Marketing.)

The garage is located off Monroe Street and across the street from the Multi-Modal Transfer Terminal. (Courtesy of Oklahoma State University, University Marketing.)

OSU opened its compressed natural gas (CNG) station in 2011. It serves as a fueling and housing station for OSU transit buses, but it also is a public fueling station open 24 hours a day, seven days a week. OSU has converted all its transit and community buses to compressed natural gas. The university has 18 CNG buses and is in the process of converting its fleet cars to CNG. By the end of 2011, OSU plans to have 90 fleet CNG vehicles. (Courtesy of Oklahoma State University, University Marketing.)

The annex, located next to the OSU Information Technology Center on West Hall of Fame Avenue, provides storage space for the library. (Courtesy of Oklahoma State University, University Marketing.)

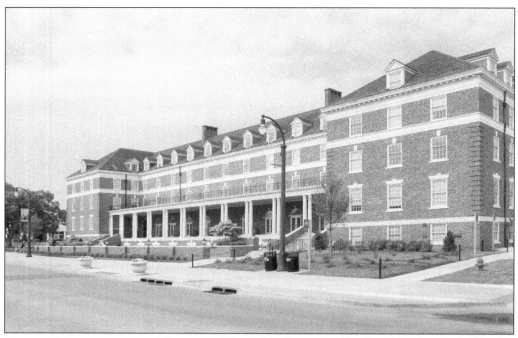

Murray Hall was converted from a residential hall to a facility for classrooms and faculty offices for the social science departments in the College of Arts and Sciences. (Courtesy of Oklahoma State University, University Marketing.)

The Division of Agriculture and Natural Resources used the latest in technology when designing the 47,000-square-foot Totusek Animal Science Arena, located adjacent to the equine center on the far west side of the campus on McElroy Avenue. Shown here is a horse riding judging competition. (Courtesy of Oklahoma State University, University Marketing.)

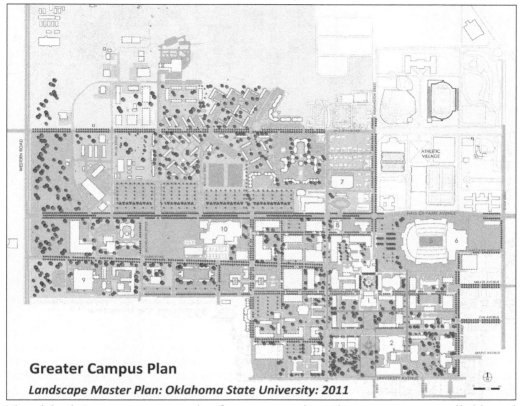

Greater Campus Plan

Landscape Master Plan: Oklahoma State University: 2011

The Alaback Design Associates plan focuses on making the campus more walkable and secure by improving and enlarging walkways and lighting systems. (Courtesy of Long Range Planning Office, Oklahoma State University, Stillwater.)

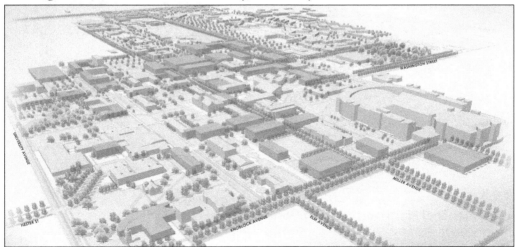

This Alaback Design Associates diagram shows the plans for a compact, but still very green, campus. An improved walkway system and parking garages located near campus help students easily change classes in just 10 minutes. (Courtesy of Long Range Planning Office, Oklahoma State University, Stillwater.)

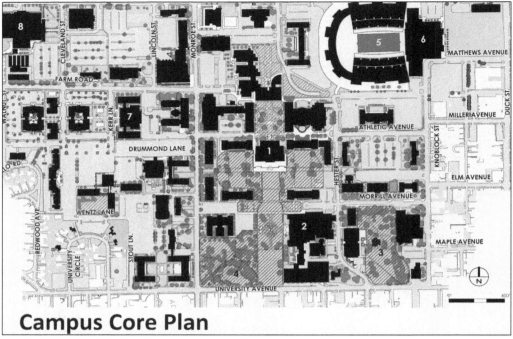

Campus Core Plan

In the plan by Alaback Design Associates, the core of the campus became more pedestrian friendly with the elimination of curbs and the use of permeable pavers to quickly absorb storm water on Monroe Street. Attractive paving patterns on the walks and streets and more street furniture were added for aesthetics and comfort, and more low-level pedestrian lighting was installed for security purposes. (Courtesy of Long Range Planning Office, Oklahoma State University, Stillwater.)

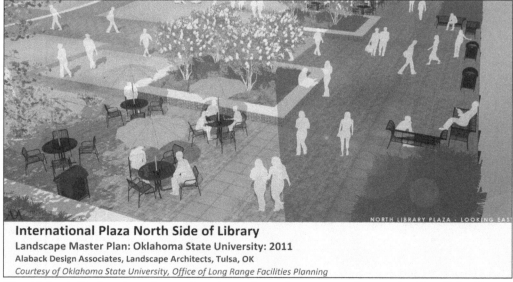

International Plaza North Side of Library
Landscape Master Plan: Oklahoma State University: 2011
Alaback Design Associates, Landscape Architects, Tulsa, OK
Courtesy of Oklahoma State University, Office of Long Range Facilities Planning

The Alaback Design Associates plan shows how the area on the north side of the library could be used for socializing. (Courtesy of Long Range Planning Office, Oklahoma State University, Stillwater.)

120

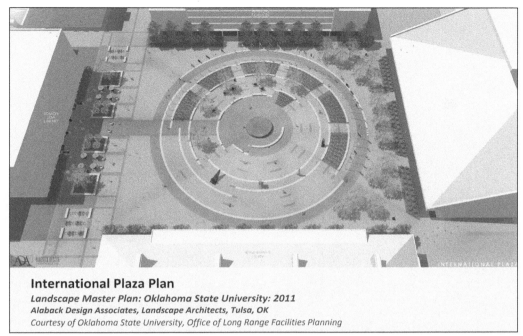

International Plaza Plan
Landscape Master Plan: Oklahoma State University: 2011
Alaback Design Associates, Landscape Architects, Tulsa, OK
Courtesy of Oklahoma State University, Office of Long Range Facilities Planning

This Alaback Design Associates diagram centered between the library and the Noble Research Center is today's International Plaza. (Courtesy of Long Range Planning Office, Oklahoma State University, Stillwater.)

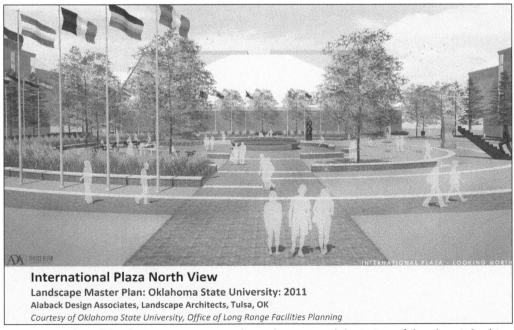

International Plaza North View
Landscape Master Plan: Oklahoma State University: 2011
Alaback Design Associates, Landscape Architects, Tulsa, OK
Courtesy of Oklahoma State University, Office of Long Range Facilities Planning

The view in this Alaback Design Associates three-dimensional depiction of the plaza is looking north from the library to the Noble Research Center. (Courtesy of Long Range Planning Office, Oklahoma State University, Stillwater.)

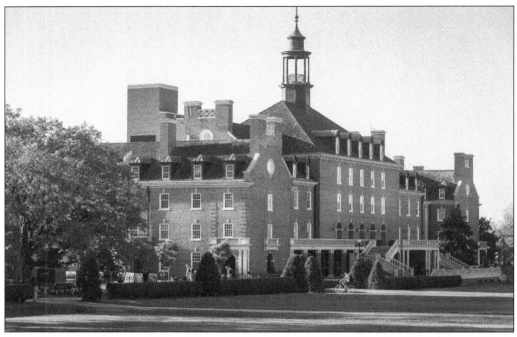

Here is a view of the student union walkway to the library. (Courtesy of Oklahoma State University, University Marketing.)

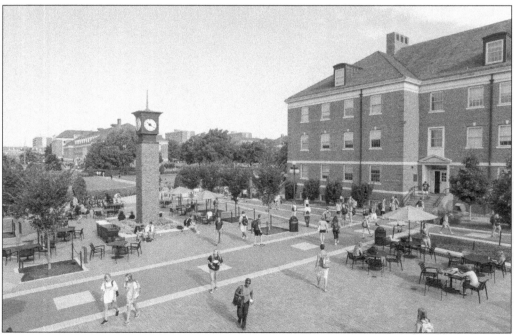

The Chi O Clock Tower was incorporated into the design of Oklahoma State Student Union Plaza. (Courtesy of Oklahoma State University, University Marketing.)

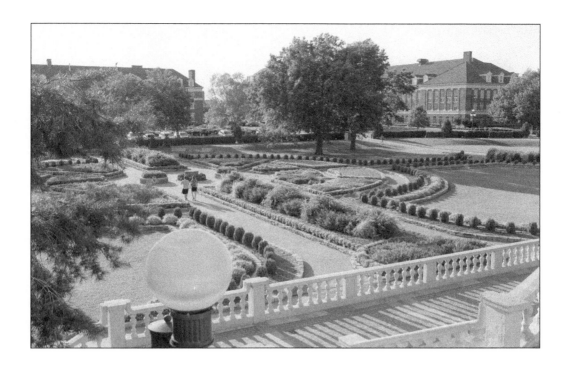

These photographs of the formal gardens were taken from the balcony of Oklahoma State Student Union. (Both, courtesy of Oklahoma State University, University Marketing.)

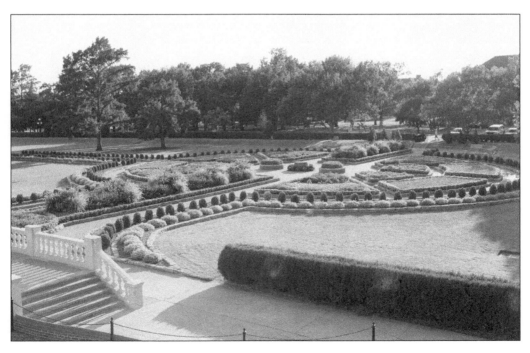

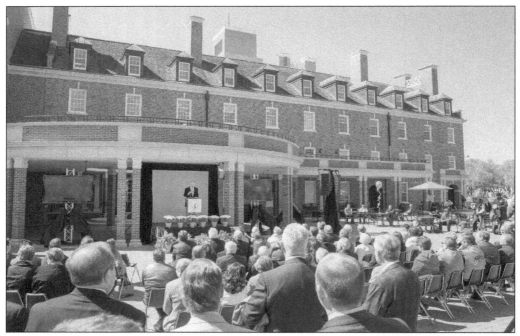

The student union was enlarged and remodeled and now has an amphitheater and outdoor dining area on the north side of the building. (Courtesy of Oklahoma State University, University Marketing.)

Here is a photograph of the amphitheater at Oklahoma State Student Union Plaza. The photograph was taken with a view looking toward the College of Business. (Courtesy of Oklahoma State University, University Marketing.)

Here, students are seen changing classes through the student union plaza. (Courtesy of Oklahoma State University, University Marketing.)

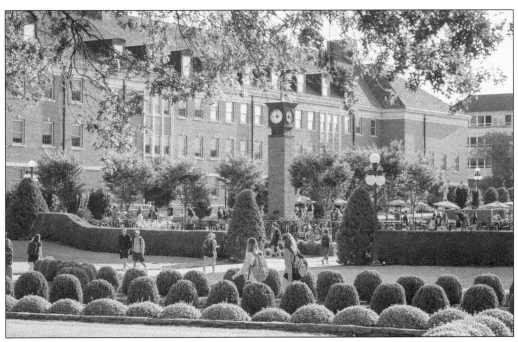

Students are walking along the mall opposite to the OSU Student Union Plaza. (Courtesy of Oklahoma State University, University Marketing.)

BIBLIOGRAPHY

Peters, David C. *The Campus of OAMC: A Pictorial History of Buildings and Facilities 1891–1957.* Stillwater, OK: New Forums Press, Inc., 2007.

Sanderson, J. Lewie, and R. Dean McGlamery and David C. Peters. A *History of the Oklahoma State University Campus, Centennial Histories Series.* Stillwater: Oklahoma State University Press, 1990.

ABOUT THE AUTHOR

Charles L.W. Leider, PhD, is professor and director emeritus of the landscape architecture program at Oklahoma State University. Prior to coming to OSU, he served as urban planning director for several leading US consulting firms. He earned a bachelor's degree in landscape architecture from Michigan State University, a master's of city planning from Yale University, and a doctorate from Oklahoma State University in environmental science with an emphasis on the preservation of cultural landscapes. He is a Fellow in the American Society of Landscape Architects (FASLA) and the American Institute of Certified Planners (FAICP). The School of Planning, Design, and Construction at Michigan State University named him a Distinguished Landscape Architecture Alumnus. Leider was awarded a Silver Medal from Universidad Nacional Federico Villarreal, Lima, Peru, for initiating a study abroad program of historic sites in Peru. The Oklahoma State Historic Preservation Office has awarded him a Citation of Merit for Publication and Citation of Merit Award for leadership in the identification, documentation, and sharing of Oklahoma's historic landscapes, which include the OSU campus, with the public.

Visit us at
arcadiapublishing.com
..